IMAGES
of America

FORGOTTEN
CHICAGO

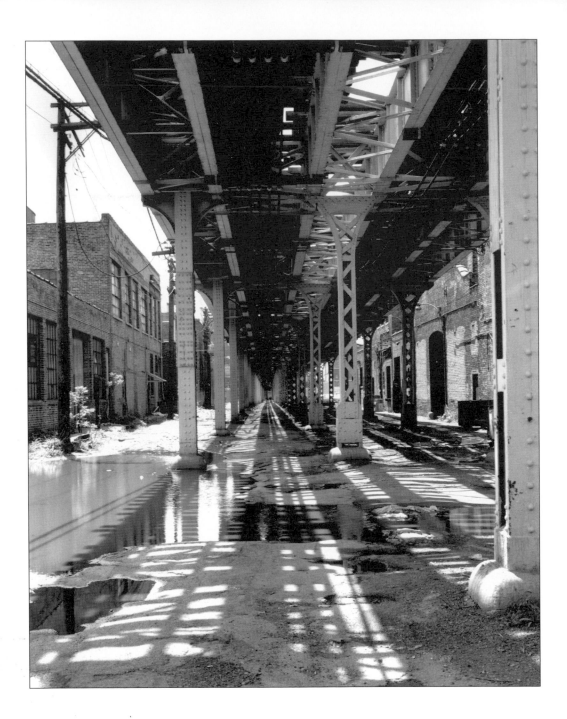

IMAGES
of America

FORGOTTEN
CHICAGO

John Paulett and Ron Gordon

ARCADIA
PUBLISHING

Published by Arcadia Publishing
Charleston SC, Chicago IL, Portsmouth NH, San Francisco CA

Printed in the United States of America

Library of Congress Catalog Card Number: 2004103635

For all general information contact Arcadia Publishing at:
Telephone 843-853-2070
Fax 843-853-0044
E-mail sales@arcadiapublishing.com
For customer service and orders:
Toll-Free 1-888-313-2665

Visit us on the Internet at www.arcadiapublishing.com

CONTENTS

INTRODUCTION

IN 1957, AN angry Frank Lloyd Wright toured the Robie House he had built in Hyde Park 50 years earlier. The home had been used as a private residence until 1926 when it was donated to the Chicago Theological Seminary for use as a dormitory. The threat of demolition of one of his masterpieces had brought the 90-year-old architect to walk through its halls again. He pronounced it as beautiful as the day it was built, noting that it "just needs a little tuck pointing here and there." Wright's widely reported comments that demolishing the historic home was "like destroying a fine piece of sculpture or a beautiful painting" galvanized members of the Chicago community. The home was purchased by Webb and Knapp, the development firm in charge of urban renewal in the surrounding Hyde Park neighborhood. Six years later, it was designated a National Landmark.

Many people date organized efforts to preserve historic landmarks in Chicago from that time in 1957. The decades surrounding that historic architect's walk through the Robie House saw widespread demolition of buildings that had stood since the early days of Chicago's development, often without regard to the historical or architectural significance of the structure. As the years went on, government and civic organizations emerged to champion the cause of a wide variety of buildings and neighborhoods. Some groups were regulatory and began to enforce restrictions on destruction or modification of significant structures. Others were advocacy groups that worked to mobilize public opinion about the importance of saving the past. In every instance, questions arose about the meaning of preservation. Did saving buildings mean finding new uses for them or was it enough to protect them from demolition?

Throughout the many battles and contests for preservation of historic structures, one form of preservation continually showed its importance in handing on a legacy of Chicago's past—photography. Preservation photographers carefully recorded buildings and districts that were about to be torn down or modified. In many cases, because of the loss of the actual buildings, the photographic record is the only thing we have today to understand the significance of buildings that were reduced to rubble. Whether there was economic justification for saving the edifices or not, the photographs are able to bring alive forgotten moments in history.

Preservation photographers frequently worked on commission from preservation organizations and councils. Groups such as the National Trust, Preservation Chicago, the Landmark Preservation Council of Illinois, the Illinois Historic Preservation Agency, and the City of Chicago Division of Landmarks employed skilled photographers to make careful record of the treasures of the past. The Chicago Historic Resources Survey compiled a database of over 17,000 properties built before 1940. The work of some of the photographers such as Richard Nickel has received special attention. His work both as a photographer and an advocate for historic preservation has been beautifully chronicled in the book *They All*

Fall Down. Other photographers such as Barbara Crane, Bob Thall, and Jay Wolke also made substantial contributions to documenting buildings that have since been demolished.

This book examines the struggle for preservation largely through the photography of Ron Gordon. Ron has worked for many of the principal historic preservation agencies of Illinois during the last thirty years. His photographs tell the stories of some of the best known losses in Chicago and the surrounding area. He also recorded some very quiet losses of diners and hotels that would be forgotten without his photographs. The story that his photographs tell has several layers. It is the story of buildings and neighborhoods that were swept away for development. It is also the story of the groups that fought to preserve the legacy of important structures. Finally, it is the story of artistic interaction between the photographer and subjects that sat mute, often in the last days before their demolition.

In some cases, Ron, like other photographers, was hired by an organization to shoot particular endangered locations. Other times, he recognized the passage of an important site on his own and photographed the building simply because he felt a record needed to be kept. These photographs give us a rare moment in time before the forces of progress pushed their way through.

Not all of the subjects in this book have been demolished. Some have been changed by huge modification or renovation. Others have left the building standing but fundamentally altered its use or social situation. Historic preservation is never without controversy. Architects for the renovated Soldier Field argue that they have preserved the monument by saving the colonnades. Critics feel that the modern stadium set in the middle of the old ring defaces its beauty.

In some cases, the forgotten part of Chicago is not a building but a way of life. In Maxwell Street, many people miss the unique institution that filled the streets with vitality on Sunday mornings. Others see a resurgent neighborhood surrounding the growing University of Illinois–Chicago. The Tree Studios were saved as buildings but the vibrant artist community that filled it was lost. The peculiar institutions of diners and cafeterias were lost to the changing tastes and eating habits of Americans. SRO hotels were replaced by new condominiums. There are probably no final answers to these debates and this book does not try to resolve them. The photographs here remember buildings and institutions that have been forgotten and the moments when many of them saw their last bits of life.

Ron's photographs tell the stories of our efforts to remember the past. When buildings are lost or altered forever, photographs provide our most important link to history. Each chapter tells the story of a particular effort at preservation. That story involves people, governments, and associations who cared desperately for the preservation of something that might be lost forever. The pictures allow us to understand the buildings as well as the tireless exertions of these people.

John Ruskin said, "Our duty is to preserve what the past has had to say for itself, and to say for ourselves what shall be true for the future." In words and photographs, we have tried to let forgotten Chicago speak for itself so that we can reflect on what will be true for our community in the future.

One

FORGOTTEN PALACES
THE RAIL STATIONS

ONE THOUSAND TRAINS came in and out of Chicago every day at the peak of the rail era. Much of the glamour and excitement of travel by train was symbolized by the train stations that gave space to those waiting to leave Chicago on vacation or business, and welcomed the thousands who entered the big city in search of dreams. Train stations were a beautiful combination of utility and decoration. Built in front of the huge train yard that held the lumbering steam engines, the stations offered space and amenities to a nation on the move. Today's passengers are accustomed to a single airport in a city which houses many different airlines. It was different in the large rail capitals such as Chicago. There were six main train terminals hosting a wide variety of lines and routes. Few passengers going through Chicago could transfer without moving from one station to another. This was a boon to the local hospitality business and it always involved a stop for a meal and frequently entailed a stay for the night in one of the city's fine hotels.

The earliest stations were built for efficiency, often in the popular Romanesque style of the time. Later stations such as Union would become great monuments to the wealth of the railroads with huge impressive waiting areas. All of them had a grace and romance that would forever be associated with the excitement of travel by train.

Today, it is easy to forget the revolution that rail travel brought to society. Generations have become accustomed to moving easily and quickly by automobile or airplane from one location to another. Before the train came into use in the decades surrounding the American Civil War, nothing could move faster than a horse could run. As a result, distant travel was a difficult and often dangerous endeavor. Pioneers trekking west spent dangerous months lumbering through difficult terrain to reach new homes. With the completion of the rail system, Americans became a people on the move. Quick, comfortable travel for relocation, business, or vacations was available to many people. This mobility was symbolized by the stations that housed arrivals and departures. In remembering the train stations, we recapture some of the joys that trains brought to people in the late-19th and early-20th centuries.

By the 1970s, rail travel had diminished severely and the consolidation of passenger traffic under Amtrak left many of the stations unneeded. Stripped of their function, the buildings disintegrated and most were demolished. In Chicago, only Dearborn and Union Stations remain. For the rest, we depend on old drawings and photographs to remember the beauty of the great train stations.

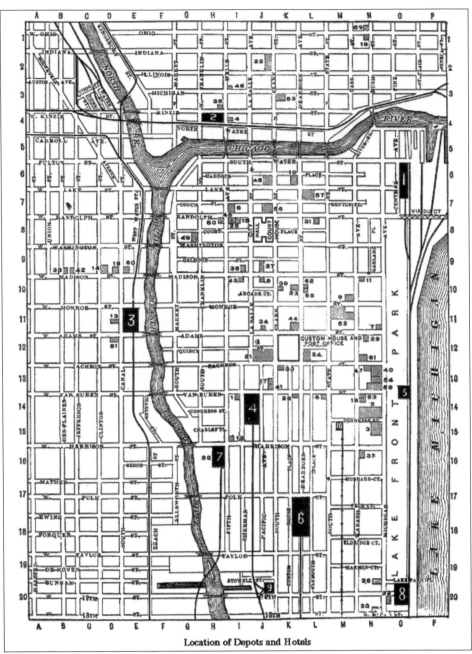

Location of Depots and Hotels

THE LOCATION OF THE GREAT TRAIN STATIONS

#3 is Union Station—the only one of the historic stations still operating.

#6 is Dearborn Station, which now houses restaurants, stores, dance and music studios, and a psychology school.

#8 is Central Station, which was demolished in 1974.

#4 is LaSalle Street Station, which was demolished in 1981.

#7 is Grand Central Station, which was razed in 1971.

Northwestern Station was at Madison and Canal just above #3.

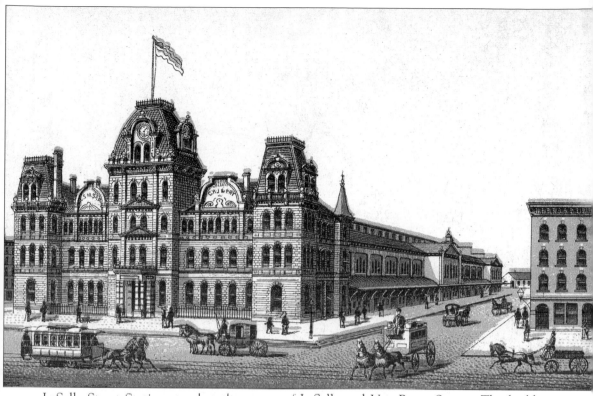

LaSalle Street Station stood at the corner of LaSalle and Van Buren Streets. The building was first erected in 1903 (Foster and Granger, architects). It was owned jointly by the Rock Island Line and the New York Central. Among the lines that served LaSalle Street were the Lake Shore and Michigan Southern; the Michigan Central; the New York, Chicago and St. Louis (Nickel Plate); and the Chicago, Rock Island and Pacific. The Lake Shore and Michigan Southern was a subsidiary of the New York Central and operated service between Chicago and Buffalo. New York Central was the only line in Chicago to use two stations (Big Four trains terminated at Central Station using rights over the Illinois Central). The Rock Island offered commuter service through Blue Island to Joliet. Rock Island passengers could join the Southern Pacific for service to the West Coast. The Nickel Plate was a tenant but never owned a part of the station. You would use the LaSalle Street Station to journey to New York, Boston, Kansas City, Denver, Dallas, and Los Angeles. The building differed from the Romanesque stations with a more business-like office complex appearance. Most of the offices were used by the New York and Michigan Railroads. The train yards extended far south across what is now Congress Parkway. The Rock Island coach yards were immediately behind the stations and the NYC yards were a few miles south. The original train yards were demolished in 1934 and two smaller houses were built. Traffic was diverted to Union Station in the early 1970s. After the station was demolished in 1981, an office building was put in its place. Metra trains to Joliet still operate from the back of the building with commuter service.

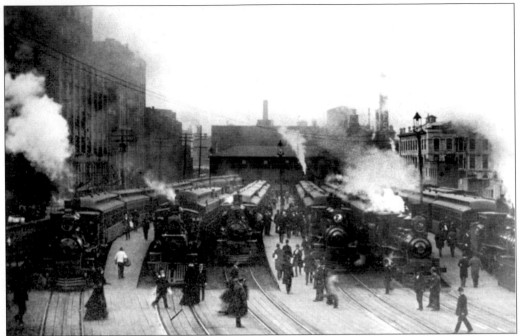

Illinois Central Station (Bradford Gilbert, architect), home to the Illinois Central Line, was located about a half block east of Michigan Avenue on East 11th Place just a block north of Roosevelt Road. It is a little hard to picture the original location because, until 1915, the lake lapped up right against the eastern side of the train station. Improvements to Grant Park extended the shoreline out much farther and significantly changed the landscape around the station. Despite the alterations, the imposing Romanesque features of the station were the dominant view of the south end of the park.

There was an earlier station on this location which had been destroyed in the Great Fire of 1871 and lay in ruins for 22 years. It was replaced in 1893 with the building pictured here. The station was built to ease passenger traffic into Chicago for the Columbian Exposition. Hundreds of thousands of visitors to the fair poured through Central Station during the short months of the exposition. An efficient and surprisingly modern system of transportation took fair-goers from the station to the fairgrounds.

From Illinois Central Station, passengers went south to New Orleans, Mobile, and sunny Florida. This station was home to some of the most legendary trains including the *City of New Orleans*, the *City of Miami*, and the *Panama Limited*. Because of these trains and the destinations of the Illinois Central Railroad, the station had a decidedly southern feel. Most stations had "secondary tenants." The Central Station also housed the Michigan Central with service eastward into its home state and the New York Central "Big Four" which served additional cities in the South.

The building was a massive undertaking which cost over $1,000,000 when it was erected. The train yard and the station were large. It could accommodate 110 passenger cars at one time. Large waiting rooms and restaurants were all furnished in the most modern style. There was even a women's waiting room to protect ladies from the more vulgar element.

The station also played a key role in one of the most culturally significant events in American history—the migration of thousands of African Americans from the South to the Northern cities. This was the largest peace-time migration in the history of the world and it fundamentally change the dynamics of American society. Encouraged by the *Chicago Defender* and black Pullman porters, people left the fields where they had labored as sharecroppers in desperate poverty to find work and a better life in Chicago. They worked hard to scrape together enough money to purchase a coach seat on the Illinois Central, which would take them north to the Central Station.

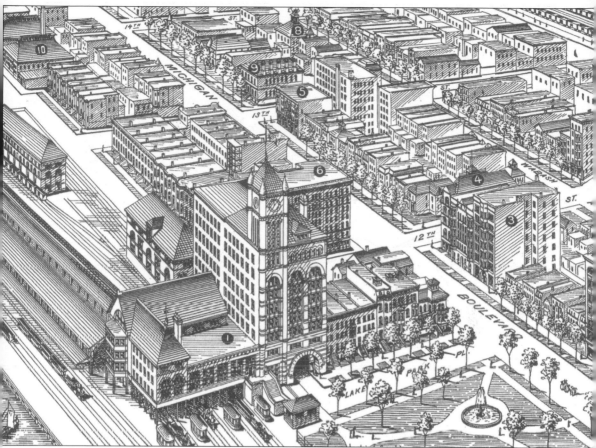

Looking south, we get an idea of the area surrounding Central Station. On the left at the bottom, we can see how close the lake came to the station. This would be filled in later to extend Grant Park which sits immediately in front of the station. Numbers 3, 5, and 6 were hotels. Passengers frequently had to stay the night in Chicago before transferring to another train. All of the stations were surrounded by hotels. These buildings dated from 1892 and were built in anticipation of the Columbian Exposition. Number 2 was a carriage factory and Number 4 was a trade school.

The station also served commuter traffic. At the bottom of the picture, slightly to the left, we can see commuter trains that went north of the Central Station to the smaller Randolph and Van Buren stations to pick up passengers who worked in the Loop area. These riders would then go to the growing south communities such as Harvey and Flossmoor. The Metra Electric Line still operates on the same route and carries Chicagoans from the south suburbs into and out of the city.

This bird's eye drawing gives a sense of the size of the train shed, which was over 600 feet long and equipped with eight tracks. The detached buildings south of 12th Street were for baggage. Waiting rooms for immigrants were located above the baggage.

During the Great Migration, porters and "redcaps" helped African-American passengers find their way to relatives, often located in nearby Bronzeville, directly south of the station.

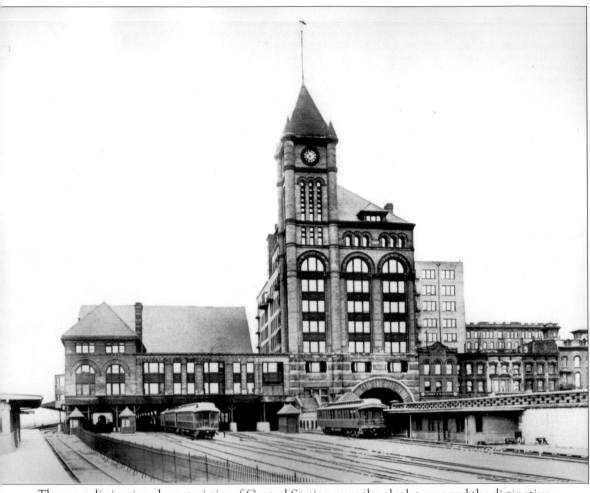

The most distinctive characteristics of Central Station were the clock tower and the distinctive arch in the center of the building. Many architects of the time derided the building as clumsy— in particular the office complex that juts out to the left of the clock tower. Louis Sullivan, in particular, singled the station out for belittlement in *Kindergarten Chats*. Despite the criticism of the exterior of the building, there were impressive interior features including a grand staircase at the entrance and a vaulted waiting room that straddled the tracks.

Because of its prominence, many Chicagoans considered the Central Station an eyesore at the south end of Grant Park. Plans were made for a neo-classical structure consisting of two levels with the lower reserved for electric commuter trains. The high price tag and a lack of support from the city killed these visionary ideas and no new station was ever built.

The station continued to serve passengers until 1972 when Amtrak consolidated service into Union Station. The station was demolished in 1974. The Roosevelt Street stop on the Metra Electric train is barely a reminder of the grand station that once stood there.

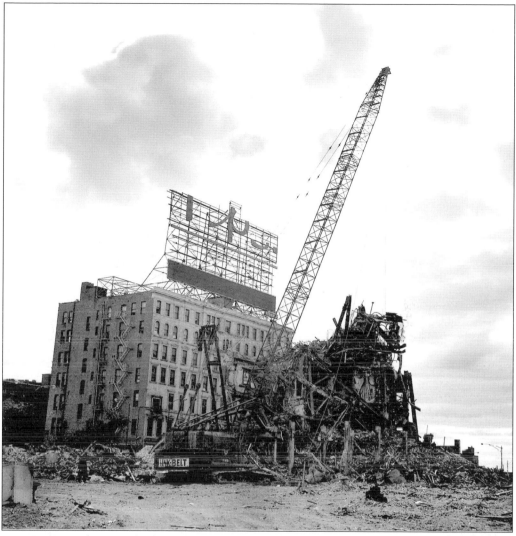

In 1974, Central Station had sat unused for two years. Considered an eyesore at the end of Grant Park, it was slated for demolition. Vibrant years of train traffic ended with the wrecking ball.

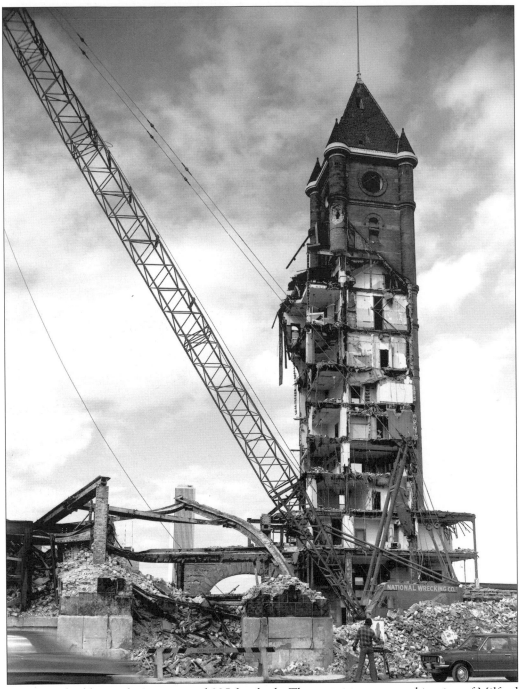

The tower had loomed 13 stories and 225 feet high. The exterior was a combination of Milford granite and Pompeian brick. Its facing is largely removed in this photo and the tower itself would fall soon.

The office building, often criticized as an ugly appendage to the station, is reduced to rubble.

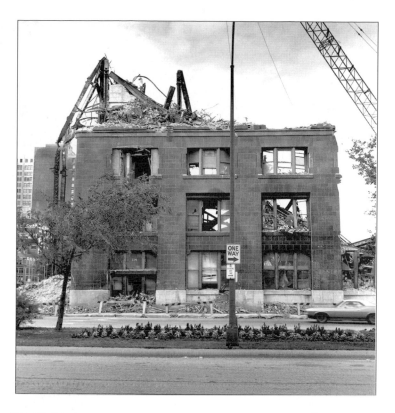

The distinctive arch stands alone as the building is destroyed around it. This arch once led to the vaulted waiting room which was the most distinctive interior feature of the station.

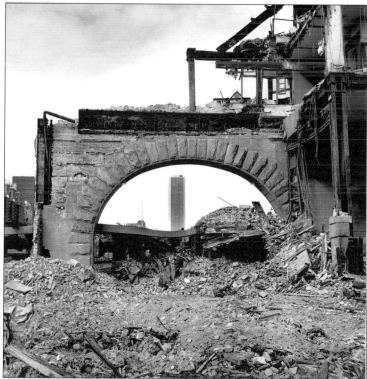

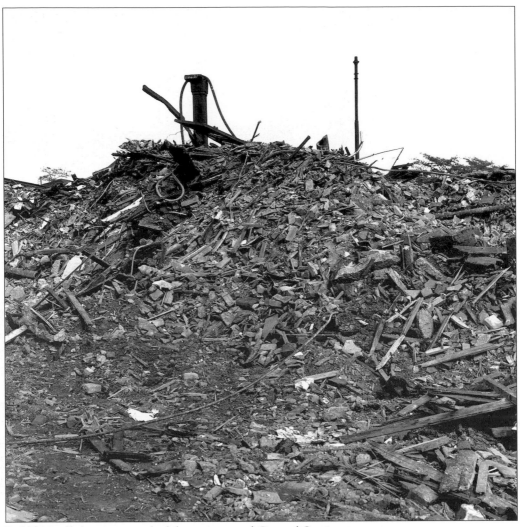

Rubble is all that remained of the once proud Central Station.

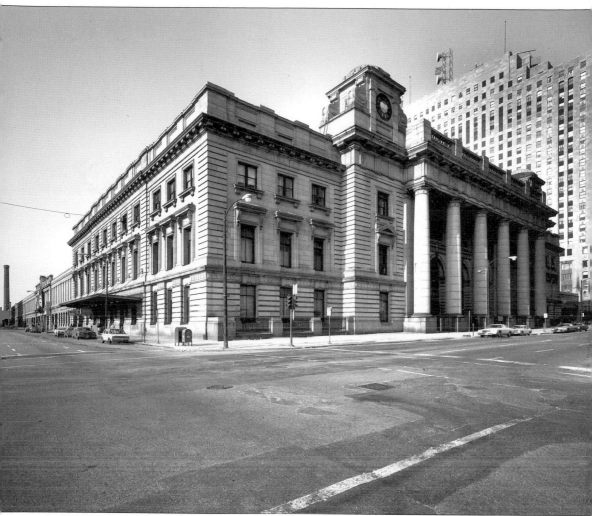

Along with Union Station, the Northwestern Station was one of the great new, more efficient stations built in Chicago. The Chicago and Northwestern Railroad had been housed in an older station built in 1881 at the corner of Kinzie and Wells. The station was cramped and inefficient. In 1911, the huge and modern Northwestern Station was built west of the Loop. As the earliest of the great modern terminals to be built in the United States, Northwestern set the standard for moving passengers easily in and out of the terminal and for handling the high volume of incoming and outgoing trains. Comparison to Dearborn Station or Central Station shows the huge transformation in size and efficiency of the Northwestern Station.

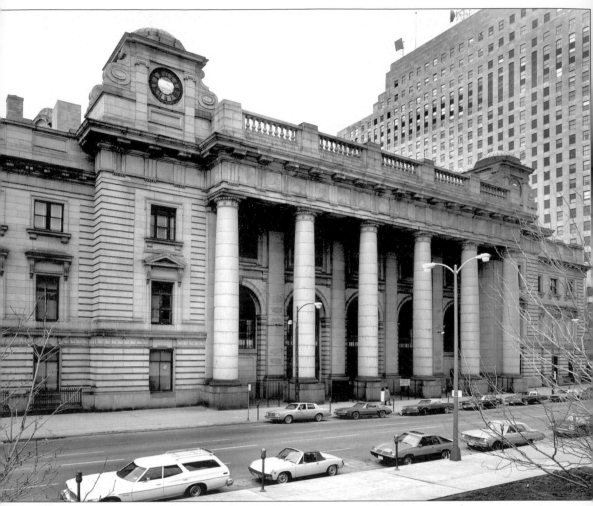

The station was designed to handle 250,000 passengers and 500 trains a day—a staggering amount of traffic. It never achieved that level even during the Second World War. The impressive front portico was the distinguishing characteristic of the Northwestern Station. Trains from this station ran to Omaha, Minneapolis, and Milwaukee. The Chicago and Northwestern Railroad was the sole tenant. The station was located at the corner of Madison and Canal Streets. The Northwestern still operates suburban commuter trains from the Ogilvie Transportation Center.

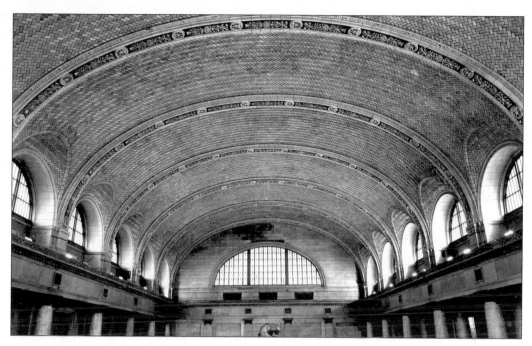

The waiting room of the Northwestern Station was its main attraction. Bathed in light from the windows in the vaulted ceiling, it provided a welcome area for passengers and attested to the power and wealth of the Northwestern Railroad. Ticket offices for commuter trains were located on the second floor.

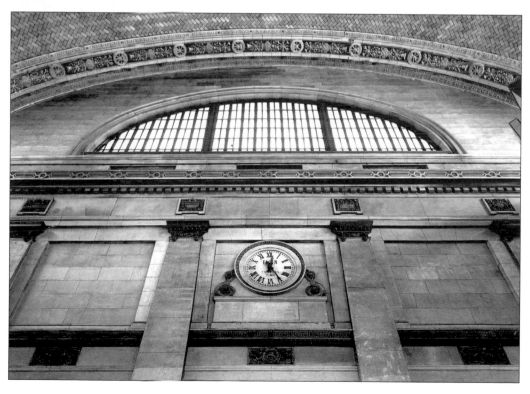

Train stations were monuments to a glamorous age of travel but they were also models of efficiency. At one point in time, one thousand trains ran through Chicago every day. Terminals needed to move equipment and people easily and quickly through the gates.

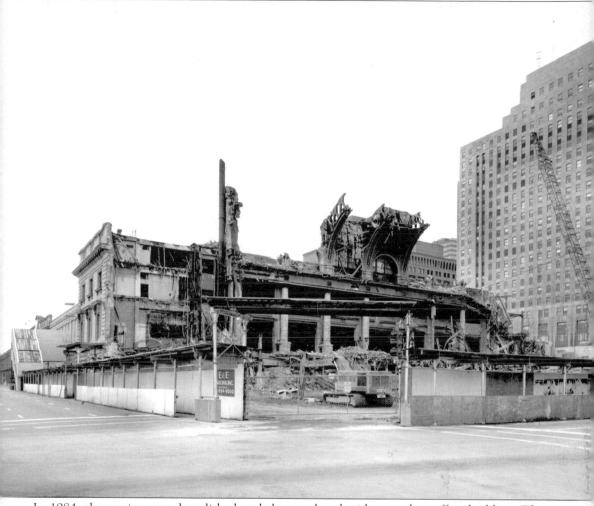

In 1984, the station was demolished and then replaced with a modern office building. The value of land west of the Loop had become too high to save the aging station. Rail service was maintained by integrating a station into the office complex. It was eventually renamed the Ogilvie Transportation Center and is used by several commuter lines.

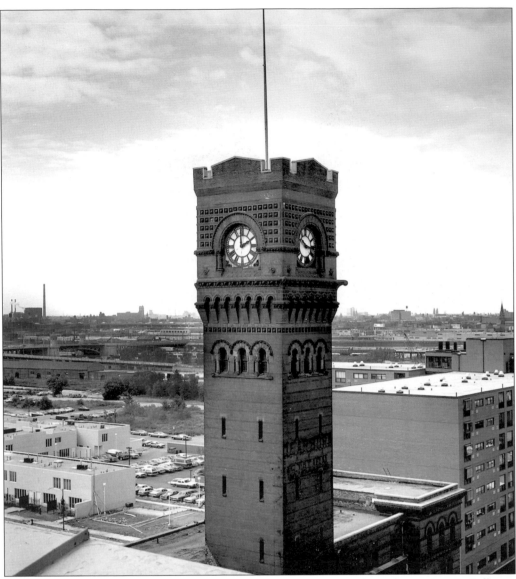

Dearborn Station dominated the area of Printers Row. Built in 1883 by architect C.L.W. Eidlitz, it is one of the best remaining examples of a Romanesque train terminal. The station was functioning fully by 1885 and was a primary entry to Chicago for streams of immigrants throughout the end of the century. It was also the arrival point for millions who attended the 1893 Columbian Exposition.

The most important tenant of the station was the Santa Fe Railroad which operated the line from Chicago to Los Angeles. Legendary trains such as *El Capitan* and the *Super Chief* were favorites of Hollywood celebrities. The arrival of film actors to Chicago made Dearborn Station a favorite place for star gazing. From the 1920s to the 1940s, it was an almost daily occasion to spot the likes of Clark Gable, Carol Lombard, Bob Hope, and others coming into the station.

The station played an important role for less luminary Chicagoans as well as a gateway to the West. Americans began to vacation in the early years of the 20th century and Chicago families traveling to the Grand Canyon or other spectacular Western sites began their trips at Dearborn Station. Because it was a gateway to the romance of the emerging Western states, Dearborn Station held a special place for Chicago families.

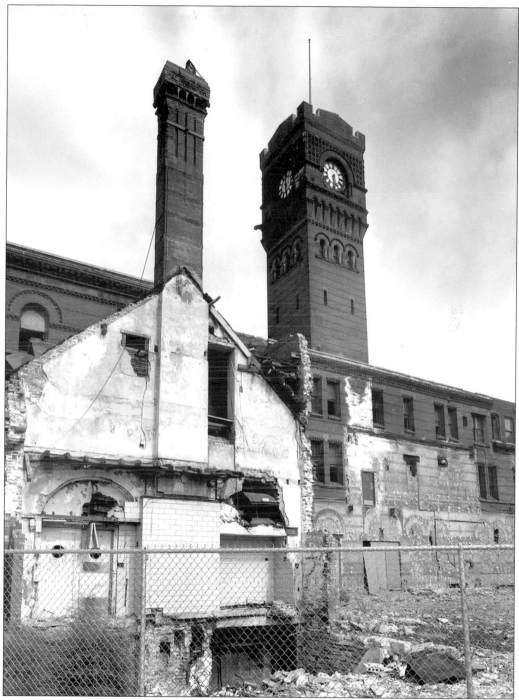

In 1971, all traffic was rerouted to Union Station. Five years later the sheds were torn down. Unlike the other train stations, Dearborn was not demolished. It has been converted into a commercial and retail mall with an attractive restaurant and other offices including the Community Bank.

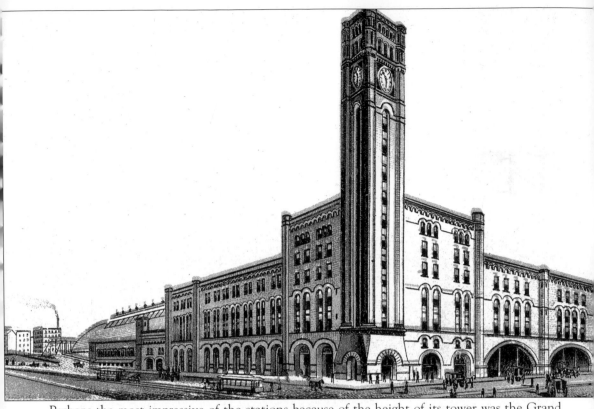

Perhaps the most impressive of the stations because of the height of its tower was the Grand Central Station. Located at the corner of Wells and Harrison, it was built in 1890. Its huge size dwarfed the nearby Dearborn Station. Grand Central housed the B&O, which went to Washington D.C.; the C&O, which ran the Pere Marquette to Grand Rapids; the Great Western with service to Minneapolis; and the Soo Line, which also ran to the Twin Cities.

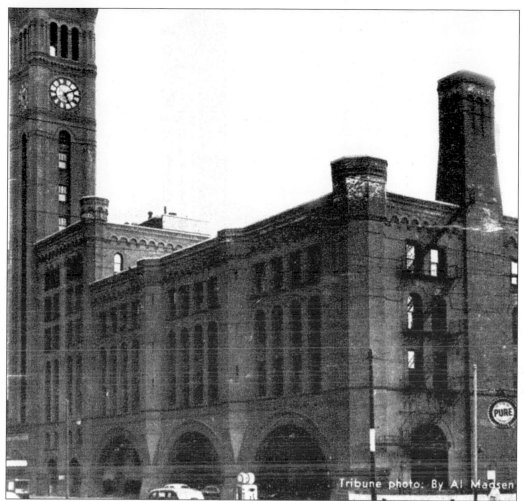

The great clock tower of Grand Central looms at the corner of Harrison and Wells. Standard time zones were instituted by the railroads in 1883 to replace the variety of local times which were often kept by sun dials. Legislation to create time zones did not come until 1918. In Chicago, the clocks in the station towers were considered the correct time.

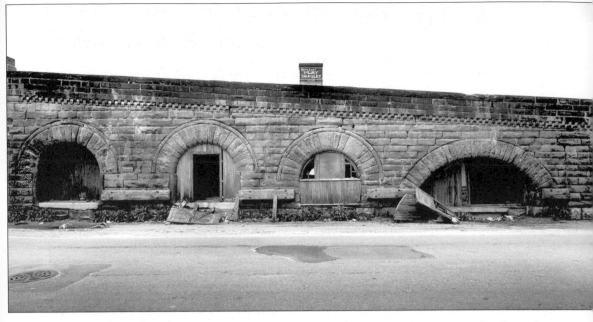

The remnants of the distinctive Grand Central arches. A portion of the arches have been reproduced in the entrance to the River City Condominiums. Designed by visionary architect Bertrand Goldberg, River City combines a very modern look with this reminder of the past. Grand Central was located just north of the River City complex.

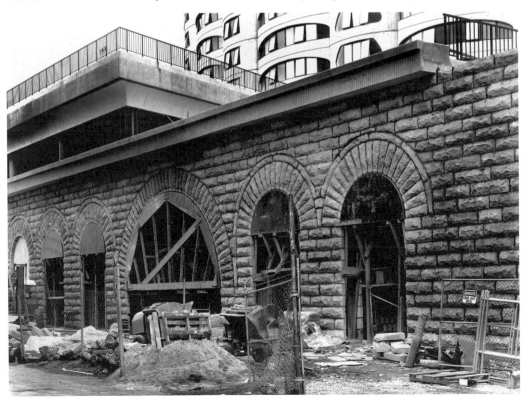

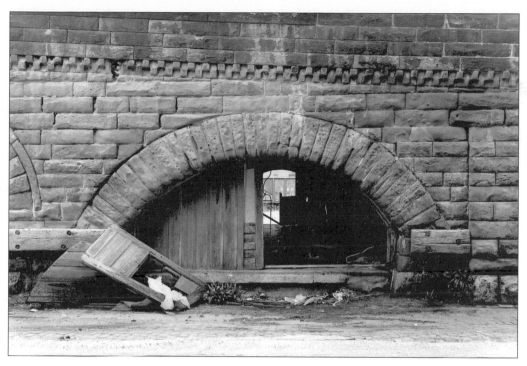

Grand Central arches varied in dimensions providing the stunning rhythm of the face of the building. Right behind the station stood the Cadaco factory, which produced the popular family game *Tripoley*.

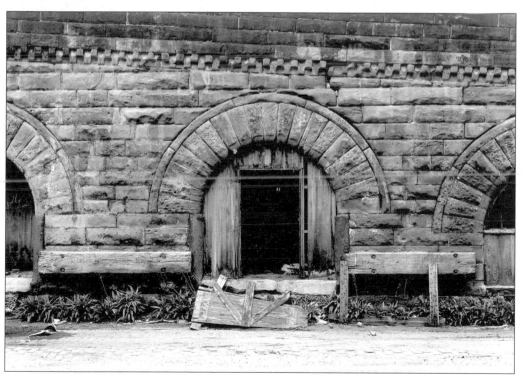

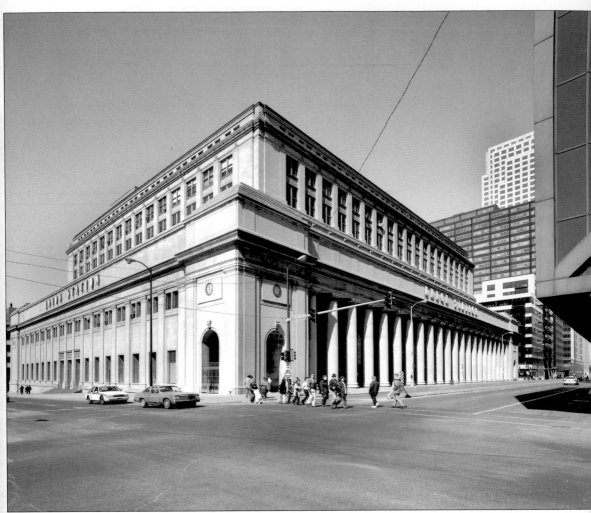

The current Union Station still stands and is in heavy use by Amtrak and commuter trains. Many Chicagoans do not know that this impressive structure replaced an earlier and smaller Union Station. Built in 1881 by a consortium of railroad companies, it became overcrowded and needed to be replaced. The group of railroads formed the Union Station Company,0 which built the current structure. Building began in 1914 but dragged on for 11 years because of shortages during the First World War and labor stoppages. The cost of the building is estimated to have been between $50 and $75 million dollars.

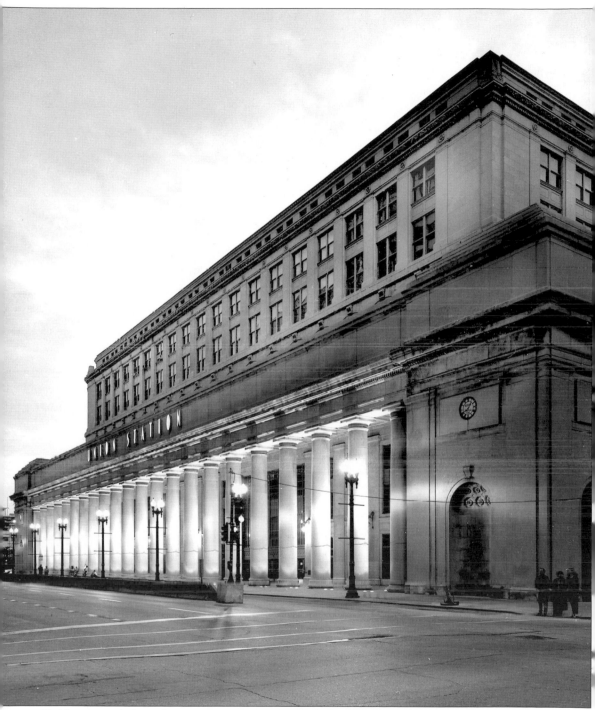

Unlike any of the other train stations, Union Station was a crossroads depot. Passengers could transfer from one line to another without having to leave the building, much to the chagrin of Chicago cab drivers. Taxi drivers were often accused of overcharging out-of-towners transferring from one station to another. Union Station provided a huge convenience for long distance travelers.

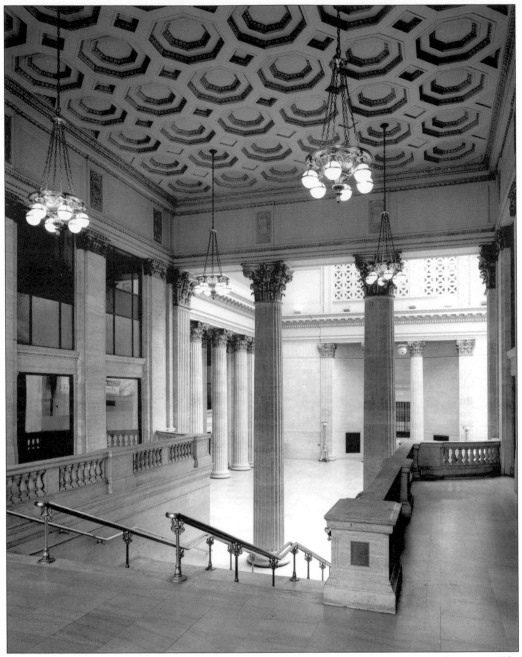

The interior stairs of Union Station provided the setting for a tense shootout in the movie *The Untouchables* featuring Kevin Costner.

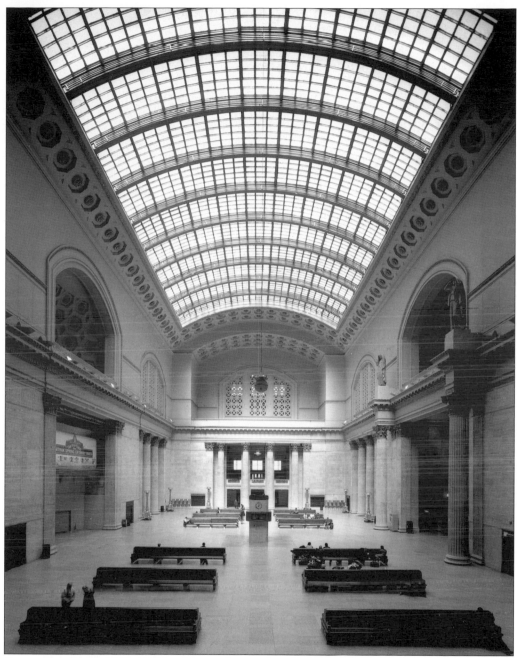

During the Second World War, Union Station handled 100,000 passengers and 300 trains a day. A significant number of those passengers were American service personnel who came to identify Union Station with canteens and patriotic displays.

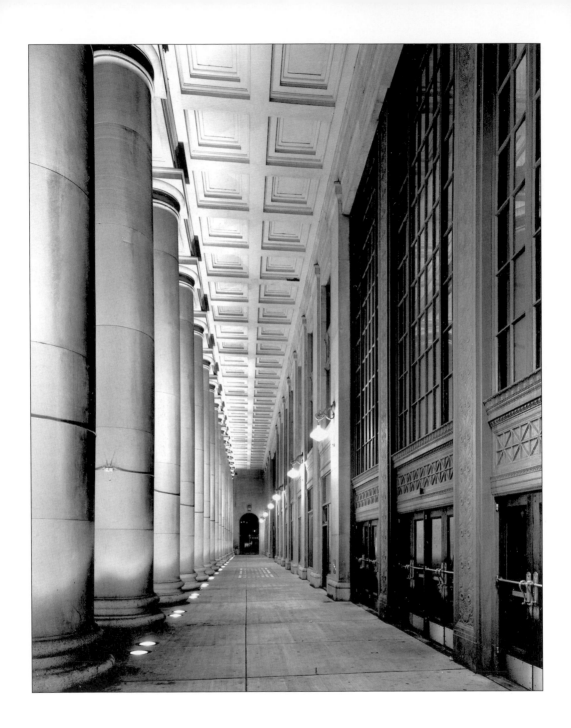

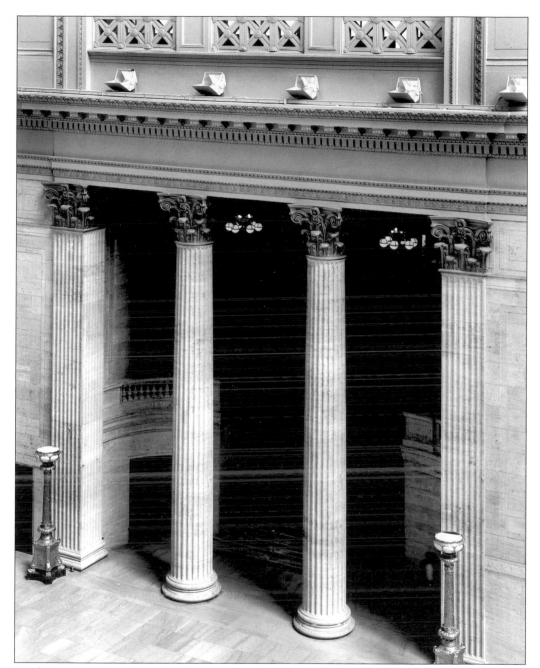

By the early 1970s, Amtrak had consolidated all passenger activity into Union Station. As a result, it joins Dearborn Station as the only depot that has not been lost. It is worth visiting both Union and Dearborn Stations. Dearborn Station is located at the end of Printers Row. A greater contrast could not exist than the one between the smaller, utilitarian Dearborn Station and the grand temple of Union Station.

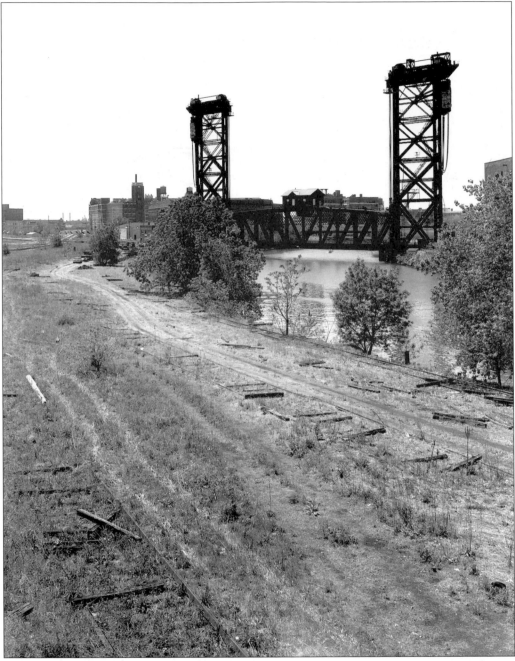

As travelers shifted to automobiles and airplanes, the great train yards were no longer needed. Some, such as the areas south of Dearborn Station and Grand Central Station, became new residential developments. An attractive river walk is being developed where the great engines once ran.

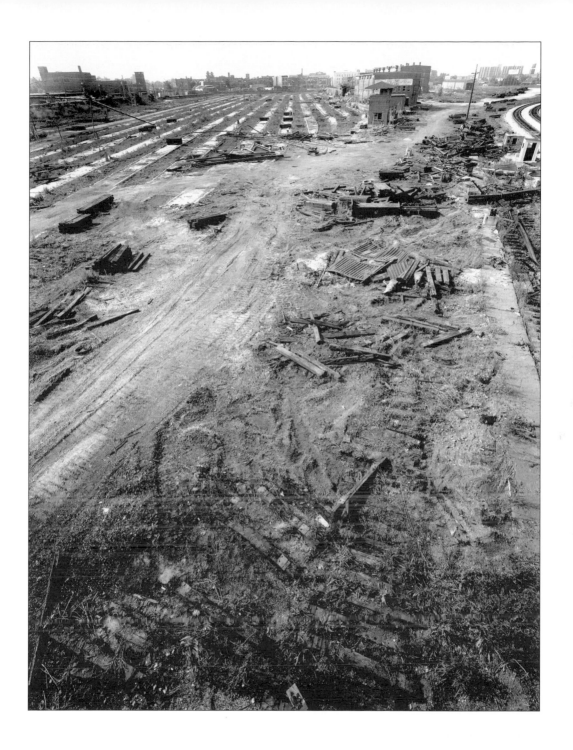

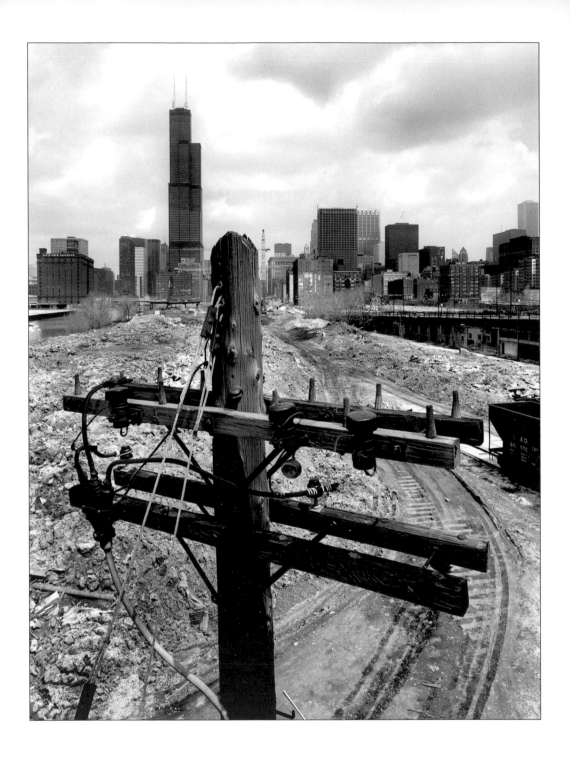

Two

FORGOTTEN PLAYGROUNDS
THE COLISEUM, THE STADIUM,
AND COMISKEY PARK

BEFORE THE STADIUM and the United Center, the center of large events in Chicago was the Coliseum located on the southwest corner of 14th and South Wabash. The history of the building stretches back to the time of the Chicago Fire in 1871. At about that time, a German immigrant named Charles Gunther opened a candy factory at 21 South State Street. Along with a wide variety of chocolates, Gunther kept a collection of Civil War artifacts in the confectionary. As the collection grew and the room in his factory grew cramped, Gunther looked to move his prizes to new quarters where they could become a tourist attraction, and he could sell souvenirs along with his signature candy.

Searching for a way to house the museum in an exciting facility, Gunther found the notorious Libby Prison in Richmond, Virginia. Next to the infamous Andersonville Prison in Georgia, the Libby ranked as the most inhumane confinement in the Confederacy. It is estimated that over 50,000 desperate Union soldiers passed through its gates during the war.

The prison was disassembled, one stone and plank at a time. In all, 200,000 stones were carefully labeled and shipped to Chicago in 132 railcars. In 1888, it was all put back together again and erected on the Wabash Avenue site. The building was an imposing Gothic-style castle complete with colonnades and spires. Inside the walls of the camp, Gunther added a small structure which he named "Uncle Tom's Cabin." This may have been the first museum gift shop in Chicago. Commemorative spoons and Libby Prison cigars were only some of the items for sale in the cabin. Across Wabash, the always enterprising Gunther added a hotel and restaurant.

It must be remembered that the Civil War had only ended twenty years before this side show was opened in Chicago. Gunther turned the horrors of the War Between the States into a circus-like attraction. While his exhibition might have been in questionable taste, it was tremendously popular. Hundreds of thousands of visitors, including many who came to Chicago for the 1893 Columbian Exposition poured through the doors of the Libby Prison to view the bed Abraham Lincoln died in and the table where Lee signed the surrender at Appomattox Court House. Many of these items can be seen in the Chicago Historical Society today.

With the passing of Civil War veterans who made up much of the attendance at the museum, visitors and revenue dropped. Gunther dissolved the museum and formed the Chicago Coliseum company. Sensing a need for a grand arena to house large events in the growing city, he built the massive Coliseum to be a political hall. With a nod to the past, the outer walls of the Libby Prison were kept and the area was built around them. While several sources identify the building of the Coliseum as 1899, it was certainly in use at least three years before that. The 1896 Democratic Convention was held there and, in 1897, there was a large fire in a manufacturer's exhibition.

After the Columbian Exposition, the South Loop turned into a seedy area including the notorious Levee District in what is now Printers Row and Murderers' Row on South State Street. In this colorful milieu, a local tavern owner named Mickey Finn created a "knock-out" drink to prey on out of town visitors. The area was dominated by two corrupt and powerful politicians,

"Bathhouse" John Couglin and "Hinky Dink" Kenna. Beginning in 1907, they held their annual 1st Ward Ball in the Coliseum. The ball became their largest fundraiser, providing the money that greased the wheels of city government and the palms of crooked police and politicians. One observer at the ball counted 2 bands, 200 waiters, 100 policemen, 35,000 quarts of beer, and 10,000 quarts of champagne. This was apparently all consumed and then the waiters were sent out for more. Commenting on his fundraiser at the Coliseum, Hinky Dink is reported to have said, "It's a lollapalooza."

The powerful political machines helped bring a record number of Presidential Nominating Conventions to the Coliseum, 25 in all. It was in the Coliseum in 1896 that 20,000 people were whipped into a frenzy when William Jennings Bryan delivered the famous "Cross of Gold" Speech. As a result of the speech, Bryan became a national figure; he was often referred to as "The Great Commoner." He would run for President in 1900, 1906, and again in 1912, always unsuccessfully. In 1912, ferocious floor fights about including Progressive ideas in the party platform forced the Republicans to add two days to the convention. The party ultimately nominated William Howard Taft to run for a second term. Although Theodore Roosevelt had handpicked Taft four years earlier, he opposed his renomination. The Republicans split on the issue of Progressivism and a splinter group walked out. They would return to the Coliseum on August 5th to nominate Roosevelt as the candidate of the Bull Moose Party.

In 1920, even though the 19th Amendment guaranteeing the right of women to vote had not yet been ratified, 27 women attended the Republican Convention at the Coliseum as delegates. Margaret Hill M'Carter from Kansas became the first woman to address a nominating convention.

The Coliseum was also the site of large religious gatherings. Aimee Semple McPherson, the controversial radio evangelist from the 1920s and 1930s, held revivals entitled "Around the World for the Foursquare Gospel." Later rock groups such as The Doors would pack fans into the Coliseum for a very different type of event.

Besides political conventions, the Coliseum also hosted athletic and music events. The Blackhawks hockey team played there from 1926 to 1929. The Chicago Bulls made the Coliseum their home for one season in 1967. In 1930, the Coliseum became the first venue for the sport of roller derby. In its first incarnation, roller derby had no physical contact. The first race called for teams to skate 3,000 miles (roughly the distance from New York City to San Diego) on a circular track in the Coliseum. In 1937, sportswriter Damon Runyon suggested adding contact to the sport. After 1920, there was little political activity in the building and it became more and more erratically used as an entertainment site.

In 1968, the site once again saw an important political moment. Anti-war demonstrators who had gathered to protest during the Democratic Convention used the Coliseum as a gathering place before marching to Grant Park. There protests would turn into violent riots that stunned a nation and became a turning point in the debate about the Vietnam War.

In 1982, the Coliseum's usefulness had been exhausted and it was demolished. Interestingly, the walls of the Libby Prison were preserved for some time after the building had been destroyed. Finally they too were lost. By this time, most of the events that had filled the Coliseum had already moved to the Chicago Stadium.

The Stadium opened in 1929 at 1800 West Madison. As with the Coliseum, it was a flamboyant impresario who conceived and built the massive structure. Paddy Harmon was born in Chicago to immigrant parents from County Kerry in Ireland. He promoted dances and managed ballrooms including the grand hall that still stands at the end of Navy Pier. From dancing, Harmon branched out to take advantage of many of the great rages of the twenties including roller skating and boxing. He was soon a major promoter of sporting and recreational events.

Harmon believed that Chicago needed an arena to rival New York City's Madison Square Garden. After working for months to secure financing, he finally was able to build a 20,000 seat facility complete with a massive 3,675 pipe organ that was said to shake the building when it was played.

Harmon would only manage the Stadium for one year. After failing to realize the original revenue goals, he was dismissed and shortly afterwards killed in an automobile accident. Fittingly, his wake was held in the Stadium. Ownership of the Stadium went to Arthur Wirtz, the father of Blackhawk's owner Bill Wirtz.

The Stadium was primarily home to sports teams and great events such as ice shows and circuses. The Blackhawks moved from the Coliseum to the Stadium in 1929. Much later the Chicago Bulls moved into the Stadium after a year in the aging Coliseum. It took many years for the basketball teams to capture the interest of Chicagoans and, during their initial seasons, they frequently played before just a few thousand fans who seemed lost in the huge arena.

Boxing matches and celebrity appearances were a big draw for the Stadium. In 1936, the popular ice skater Sonja Henie performed an ice show before a packed house. Boxer Tommy Loughran defended his light heavyweight title there against Mickey Walker in 1929.

In 1932, both political parties held their conventions at the Stadium. At the Democratic Convention, Franklin Roosevelt became the first presidential candidate to appear in front of the delegates to give an acceptance speech. Upon hearing Roosevelt "pledge (himself) to a new deal for the American people," the organist began to play a popular song of the time "Happy Days are Here Again" which quickly became FDR's campaign song. More soberly, thousands packed the Stadium for the funeral of Mayor Anton Cermak in 1933. Cermak had been killed in an assassination attempt on President Franklin Roosevelt.

By the 1980s, many people began to see the Stadium as obsolete. In 1991, the owners of the Bulls and the Blackhawks agreed to build the state of the art United Center as a replacement. In 1995, despite efforts to preserve it, the Stadium was torn down.

What the Coliseum and the Stadium were to indoor sports, Comiskey Park was to outdoor activities. The home of several baseball teams and a professional football team, Comiskey was the center of sports activity on the South Side for 80 years. Comiskey was built in 1910 as one of baseball's first modern steel and concrete facilities. Before Charles Comiskey purchased the land at 35th and Shields, it was owned by Mayor "Long John" Wentworth and used as a city dump. Trash would often resurface years later. It is reported that baseball player Luke Appling tripped on a kettle that had worked its way to the surface. After several expansions, seating finally reached 52,000. It was so large that, when the Cubs reached the 1918 World Series, they borrowed Comiskey to play the games.

Besides being the home of the Chicago White Sox, Comiskey was also the permanent home of the East-West All Star Game of the Negro League. It was the home of the Chicago Cardinals football team for 35 years. Although the focus of Chicago was usually on the more successful Bears, the Football Cardinals had the same grip on South Side Chicago that the White Sox have maintained. The first baseball All-Star Game was played in Comiskey in 1933.

The park always seemed to reflect the struggle of the changing realities of baseball. The large outfields were partly designed by a pitcher named Ed Walsh, who worked with architect Zachary Taylor Davis in laying out the field. During the "dead ball" era of baseball, the dimensions worked well, but as the sport turned to home run hitters, the long distances to the fence made it unpopular with fans who looked for high scores. In 1949, a fence was added to reduce the length of the outfield, but it benefited the opposing teams more than the White Sox and was removed after a few games.

In 1960, owner Bill Veeck added fireworks and spinning wheels on the scoreboard to create fan interest. The showmanship of the colorful owner changed the presentation of baseball throughout the league, but Veeck was always short of funds and had to sell the team. New owners Jerry Reinsdorf and Eddie Einhorn received taxpayer funds to modernize the old park but still campaigned to have the stadium replaced because of structural deficiencies.

Comiskey always had unusual events—some planned and some spontaneous. In 1959, a helicopter landed on second base before a Sox-Indians game and four "spacemen" jumped out to kidnap infielders Nellie Fox and Luis Aparicio. Later that season, a game was delayed by a swarm of gnats. When bug spray failed, the groundskeepers brought in the post-game fireworks

and attached a smoke bomb to the tails. The gnats were dispersed and the game continued. Opening day of 1974 was highlighted by strippers and streakers. In 1974, in the middle of a double header, Disco Demolition Night incited fans to storm the field. The White Sox had to forfeit the second game.

Finally, under the threat of the White Sox moving to Florida and some heavy political pressure, a new baseball park was approved. In 1990, Comiskey was torn down. A new stadium which is now called U.S. Cellular Field was erected next to the old field. Time had finally caught up with the 80-year-old playground.

The Coliseum, the Stadium, and Comiskey all fell victim to changing economics of sports and entertainment. As teams and events moved to more modern and lucrative locations, they became part of forgotten Chicago.

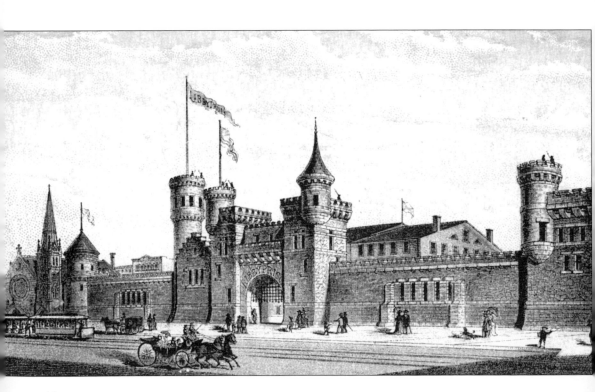

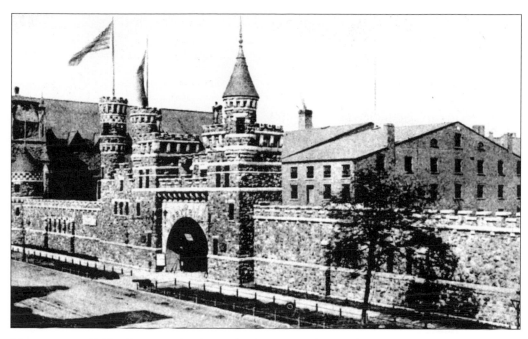

The notorious Libby Prison in Richmond. Next to Andersonville, it was the most inhumane camp in the Confederacy. One witness said, "In Libby prison, a crumb of bread was worth its weight in gold."

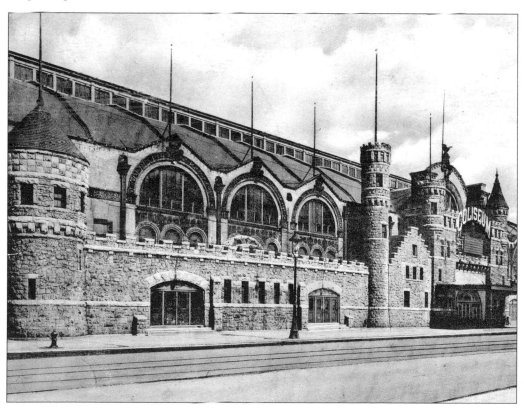

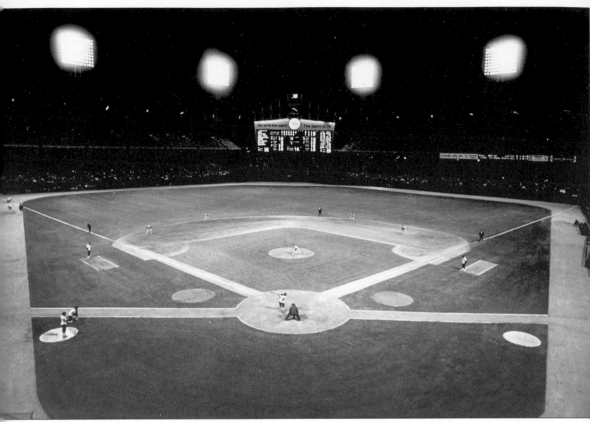

Old Comiskey is seen here at night. The sprawling outfield was a hitter's nightmare. One of baseball's most innovative uniform ideas came from Bill Veeck's wife Mary Francis in 1976. Pull over jerseys were worn pajama style outside the trousers and featured a v-neck simulated collar. The effect was a throwback to olden days but it never caught on in the rest of baseball.

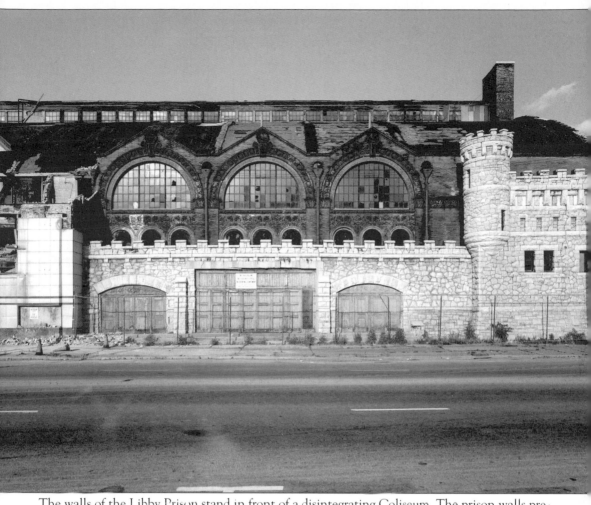

The walls of the Libby Prison stand in front of a disintegrating Coliseum. The prison walls predated the Coliseum and would last several years after its destruction.

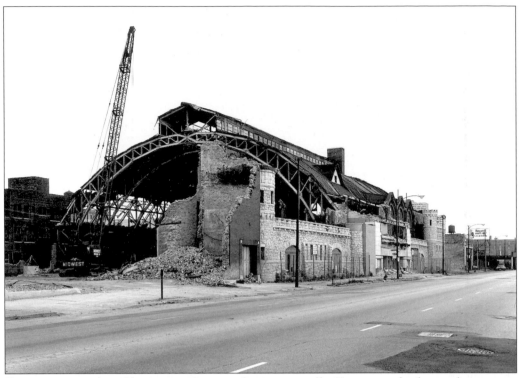

Cranes remove the old structure leaving the prison walls. Few passersby knew the amount of suffering that had gone on behind those stones when they held Union prisoners in Richmond.

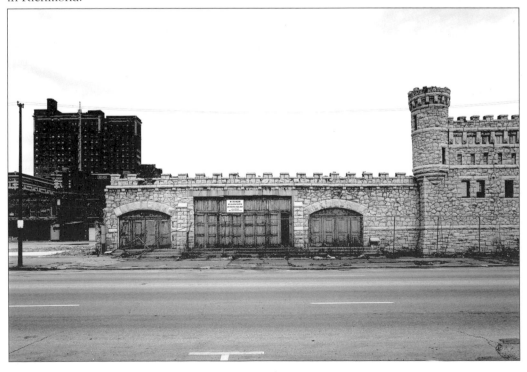

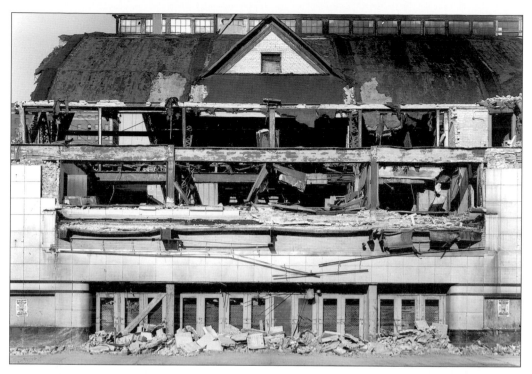

The demolition of the Coliseum revealed a history of development. Modern restyling of the entrance areas mixed with old frame and prison stone.

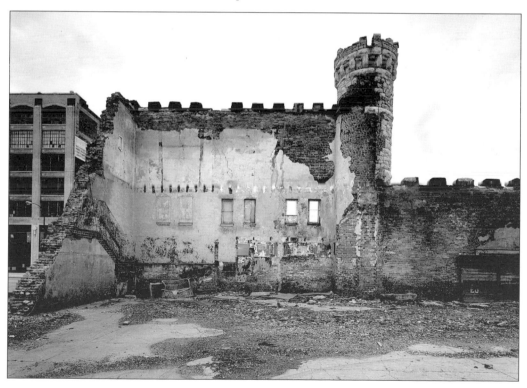

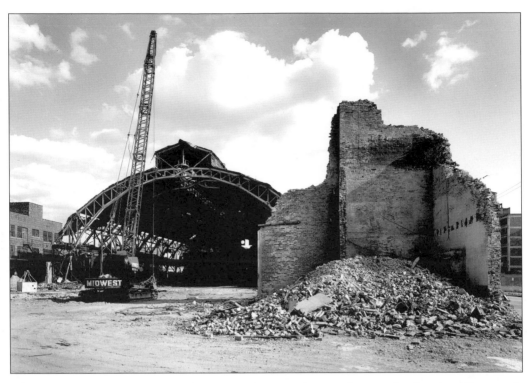

The cavernous interior of the Coliseum was home to huge gatherings for decades. The sounds of political conventions and sporting events resonated within its arches.

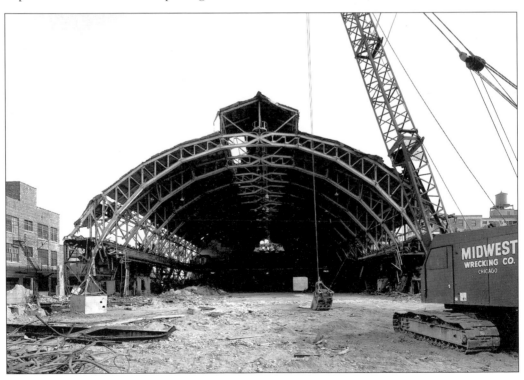

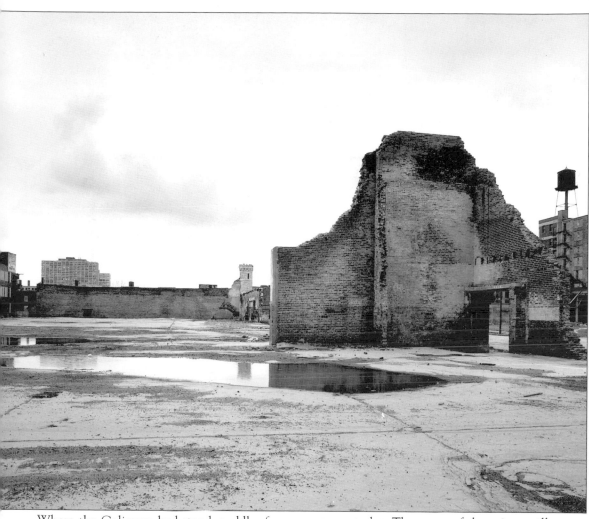

Where the Coliseum had stood, puddles form on an empty lot. The turret of the prison still stands in the distance. It would be removed later.

Alonzo Smith

One Sunday morning as I was roaming around the city looking for pictures, I came across an old frame building standing alone in a huge parking lot in front of the Chicago Stadium. As I was setting up my camera, I noticed a man with a broom way off in a corner of the lot. He had been sweeping standing water out of the low spots in the asphalt paving. Now he was watching me. He approached me and asked, somewhat suspiciously, what I was doing. I told him that I wasn't doing anything official, but just interested in the contrast of the little old frame house against the imposing stadium.

He told me that it was his house and that he had owned it for a long time. The people from the stadium were trying to buy the house and had offered him $14,000. He told me that he had worked for the railroad all his life and that he was retired and in his seventies. He said that if he took the $14,000, he would be on welfare next year and that he didn't want to live like that.

I asked him to be in the picture and he agreed. You could see the resolution in his face. I wondered why they didn't just give him the money to fix up the old house and then just hire him to be the caretaker of the grounds. Now the stadium is gone and the old house is no longer there, and I don't know whatever happened to Mr. Smith.

—Ron Gordon

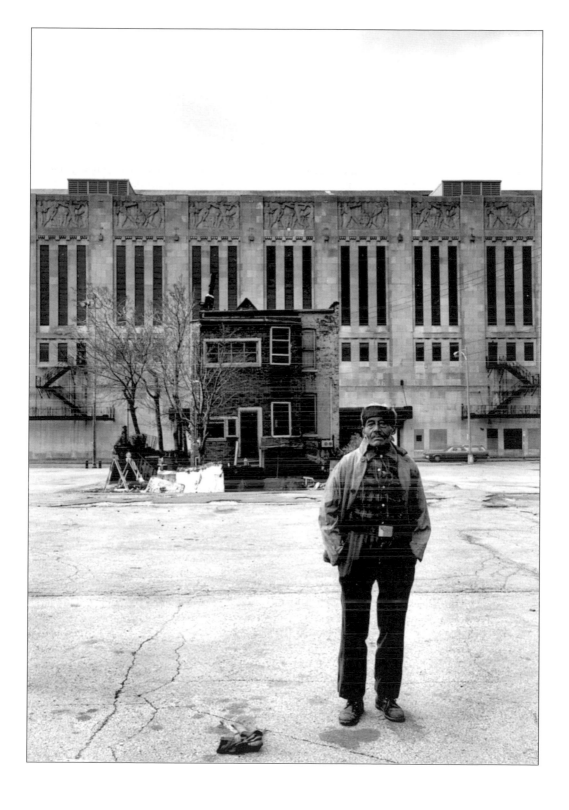

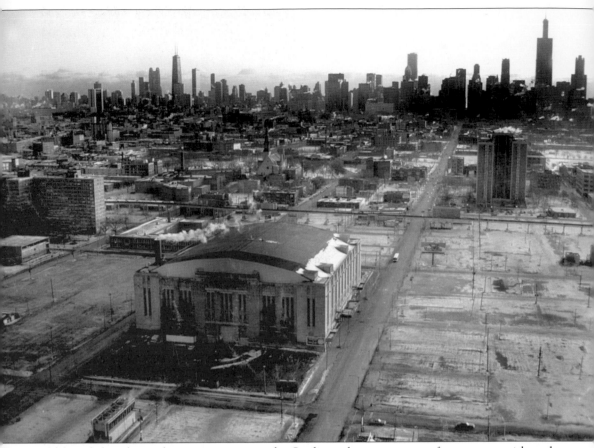

Although best know for sporting events, the Stadium also was a venue for concerts with such different artists as Frank Sinatra, Bing Crosby, Elvis Presley, and Led Zeppelin.

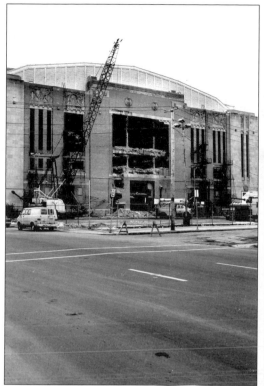

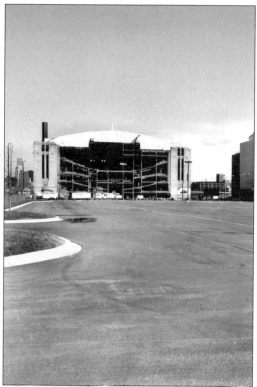

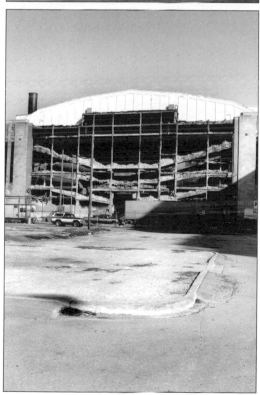

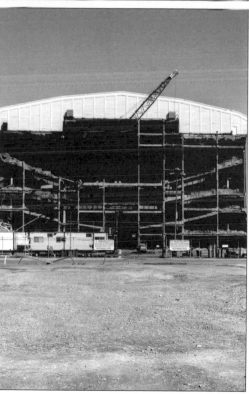

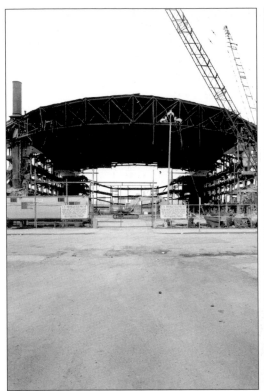
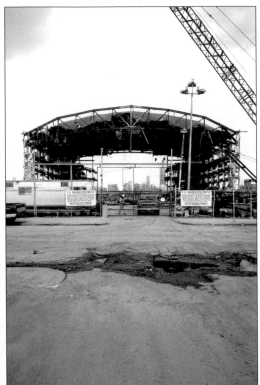
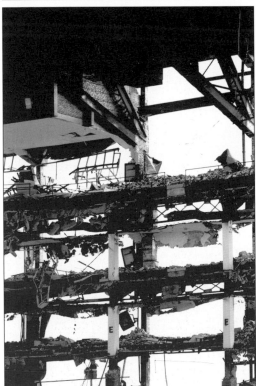
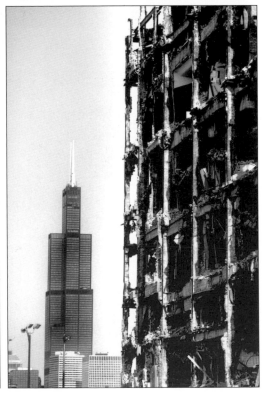

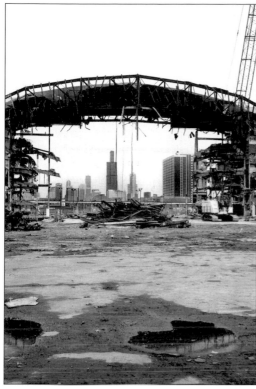

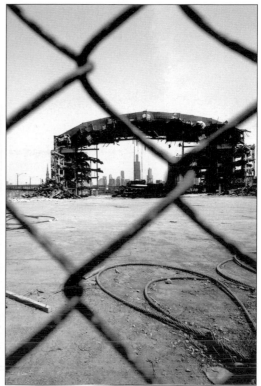

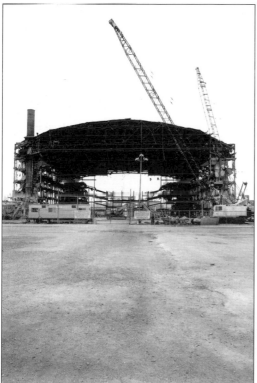

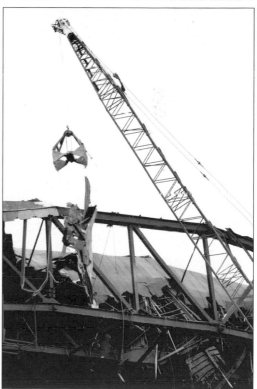

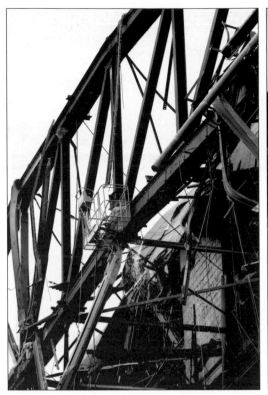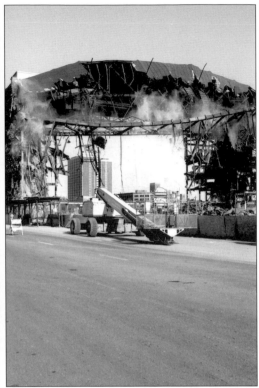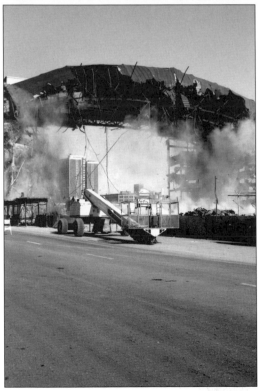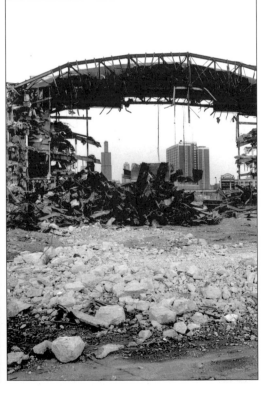

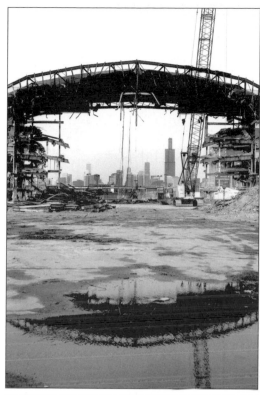

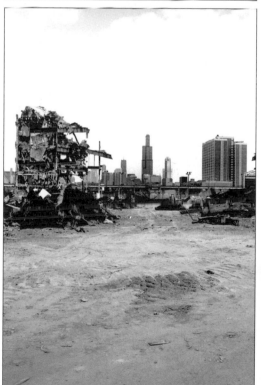

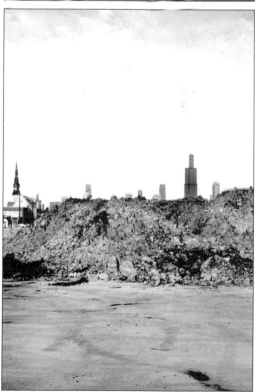

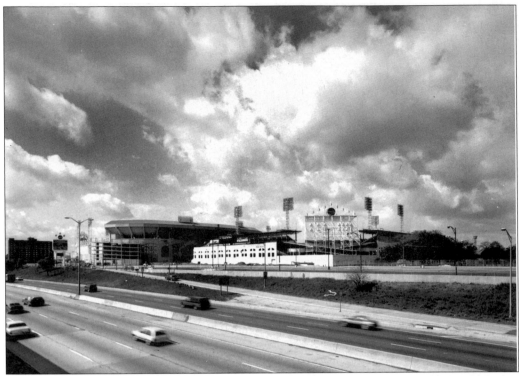

The demolition of Comiskey Park happened after the new ball field was built. A memorable scene in the popular John Candy/Maureen O'Hara movie *Only the Lonely* captured the sense

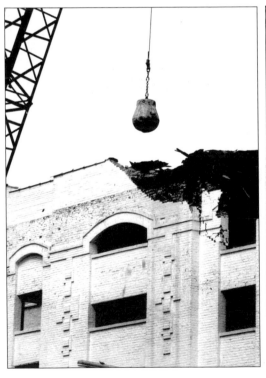

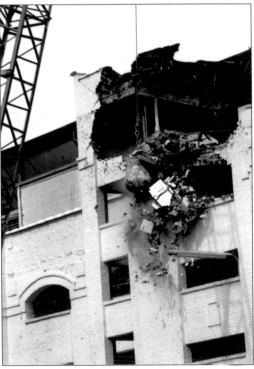

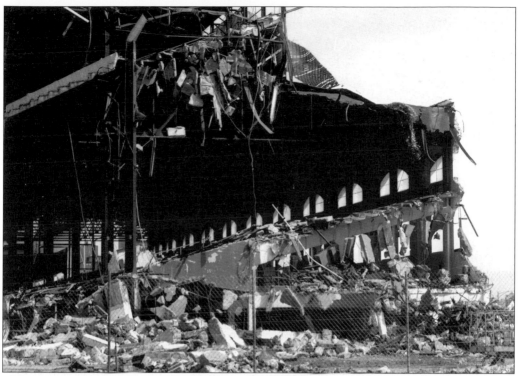

of loss many Chicagoans felt. In it, Chicago policeman Danny Muldoon entertains the shy Theresa in the infield of historic Comiskey—soon to be rubble.

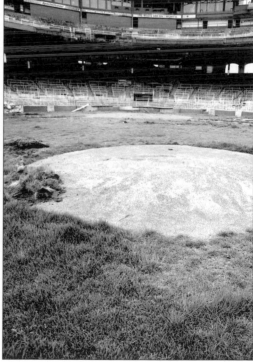

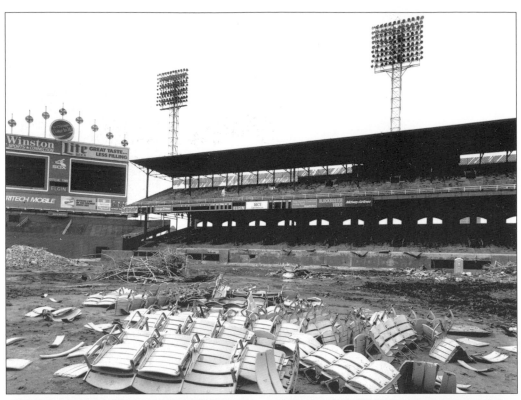

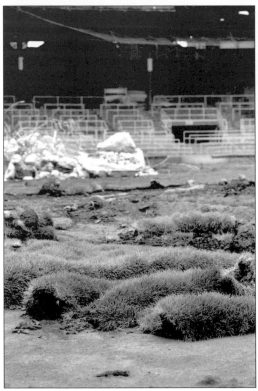

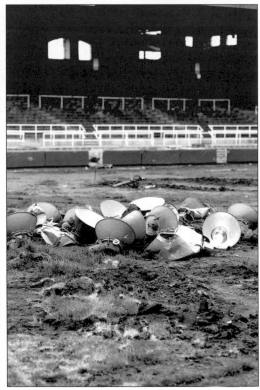

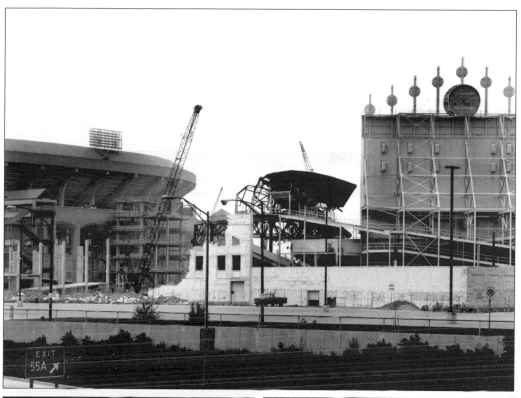

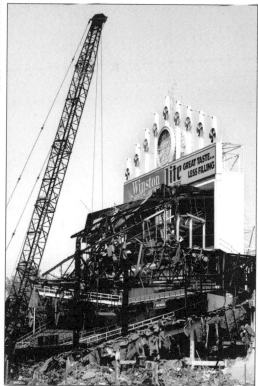

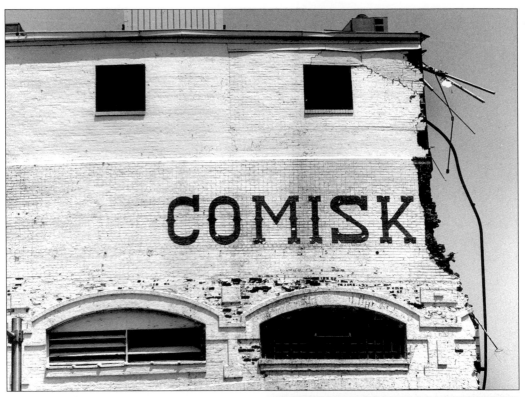

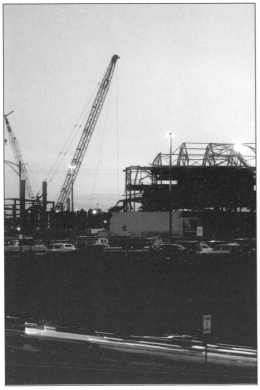

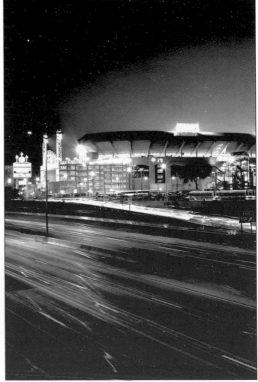

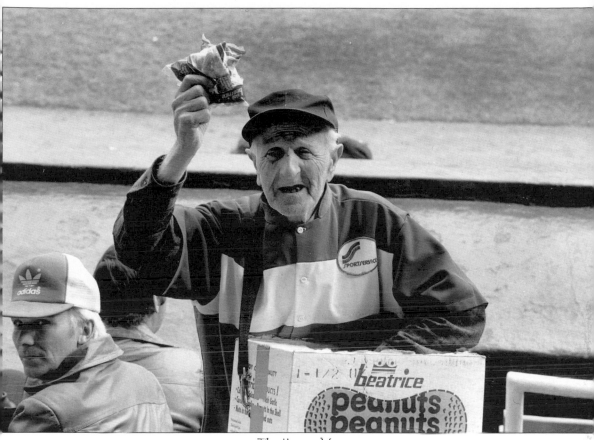

The Peanut Man

In the late fifties, at the age of sixteen, I got a job as a peanut vendor at Comiskey Park. There, I first ran into the Peanut Man. He was younger then, and I didn't think much about it. But many years later, in the early eighties, much to my surprise, he was still there. This time, as an old man, he conjured up the imagined image of the man inside the peanut. I never got to know him or even know his name, but I got his picture. His was the face of a lifetime of hard work and independence and a million miles of stairs at the old ball park.

—Ron Gordon

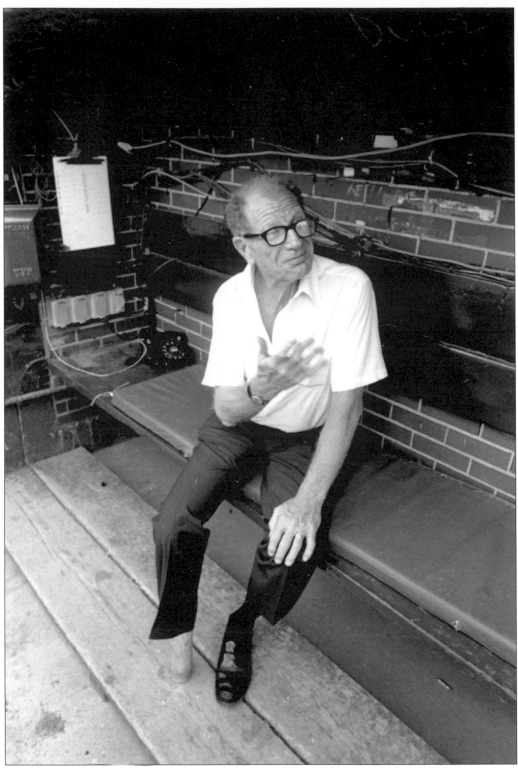

Bill Veeck (1914–1986).

Three

FORGOTTEN AND UNNOTICED
DINERS AND SRO HOTELS

NOT ALL LANDMARKS are famous buildings or organizations. Beyond the train stations and the great stadiums, there was always a part of the population struggling to make ends meet and sometimes barely holding on to the necessities of life. For the very poor, SRO (single room occupancy) hotels provided inexpensive living quarters. The hotels dotted the city, especially in the South and West Loop. Located in neighborhoods with names like Whisky Row and Skid Row, they were rarely seen by many Chicagoans. As urban redevelopment progressed, many of the SROs have given way to new condominiums and apartments. In some cases, the same buildings that housed the indigent have been refurbished to offer city living to the more affluent. The residents of the "flophouse" hotels have moved on to try and find new lodging.

Diners and cafeterias were the restaurants of the working class. Before the era of national chain fast food restaurants, the city was full of eateries with basic food at an affordable price. Locals had grown accustomed to the unique and often idiosyncratic nature of these restaurants. As Americans began to travel across the country on the growing freeway system, they looked for familiar and dependable chains of restaurants. The quirkiness of local diners did not suit the needs of travelers who demanded predictability. Howard Johnson restaurants and then later McDonald's fit the tastes of Americans looking for uniformity. The local eateries often fell victim as the chains found locations within the city.

Eateries and small hotels do not have the distinctive history of the Coliseum or the great train stations. Few of the names of the people who ate and slept there are remembered. Many people involved in preservation would question the value of remembering (much less saving) these kinds of buildings and institutions. For most, the small diners and unnoticed hotels became part of urban blight that needed to be removed for more modern and upscale buildings. While the structures may not have been architecturally or historically significant, there is a sociological loss as these parts of the city get swept away. Places such as the National Cafeteria, where the "Hot Dog Special" was $1.59 and Tony's Diner, where you could easily put on an extra ten pounds, provided texture and color to the city. In many cases, when they were removed, the space was used for a parking lot.

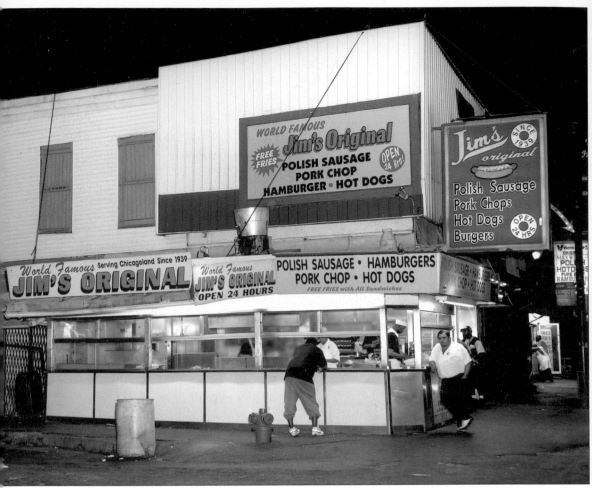

Jimmy Stefanovic began his hot dog business at his aunt's street stand in 1939. Eventually, he was able to buy the building which had been a delicatessen. It was operated by the family at this location until 2001. The restaurant was famous for red hots and Polish sausages.

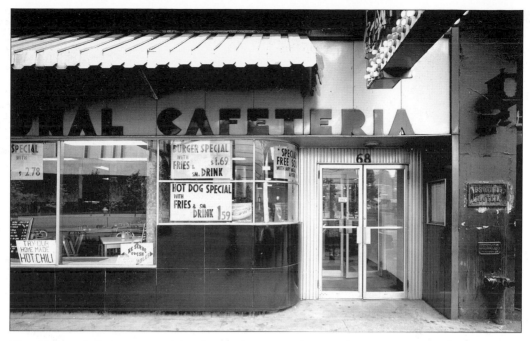

The National Cafeteria on Van Buren Street in the South Loop offered affordable food in a clean, if somewhat institutional, setting. It was owned by Greek immigrants. William Touloumis, a chief architect of the Walgreen's Drugstore chain and later chairman of a major development company in Florida, arrived in this country from Greece just after 1950 and was given a job wiping tables in the National Cafeteria by his fellow countrymen. From here, he worked to become one of the most successful businessmen in South Florida. His story is typical of the hopeful immigrants who found employment in the restaurants of Chicago.

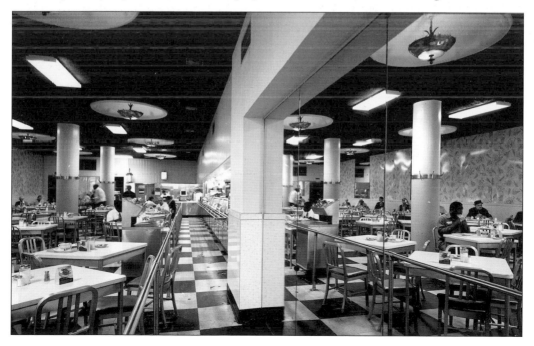

No one sat for free at the National Cafeteria. A minimum of 25 cents was always charged. The South Loop was considered the "seedy" part of Chicago then. Only in recent years has new development begun to grow in the area. The old hotels and diners were casualties of the growth.

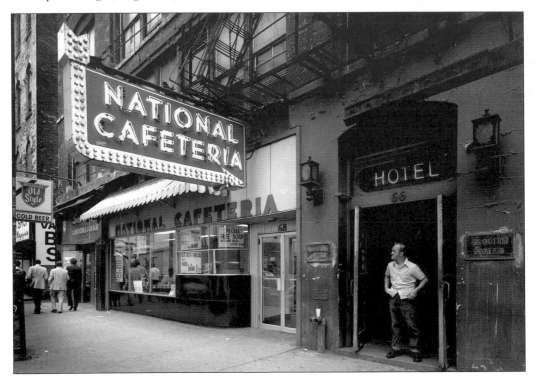

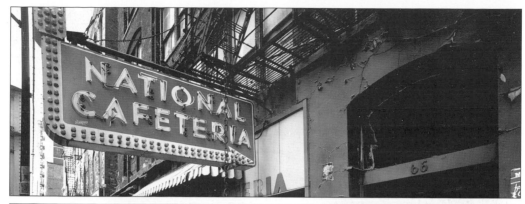

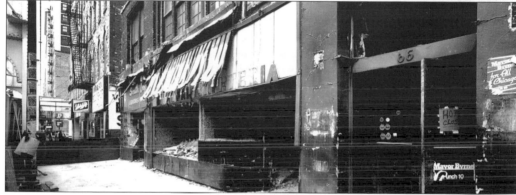

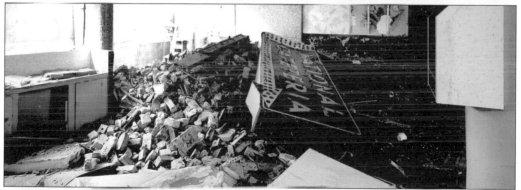

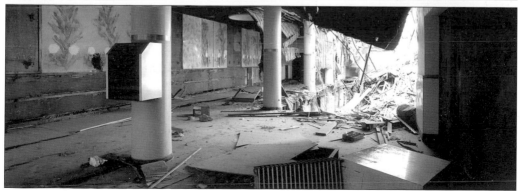

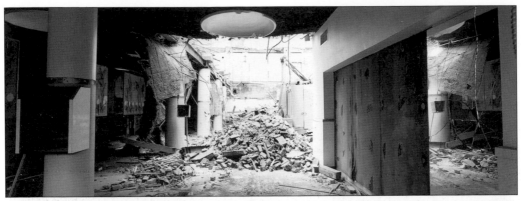

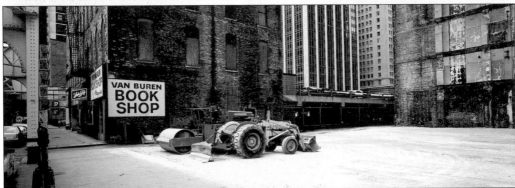

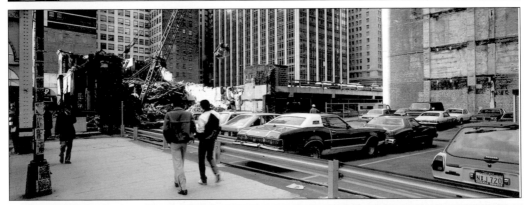

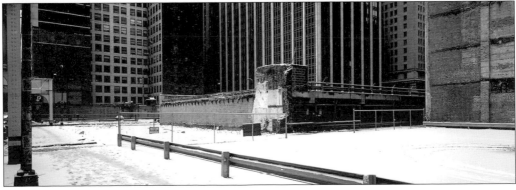

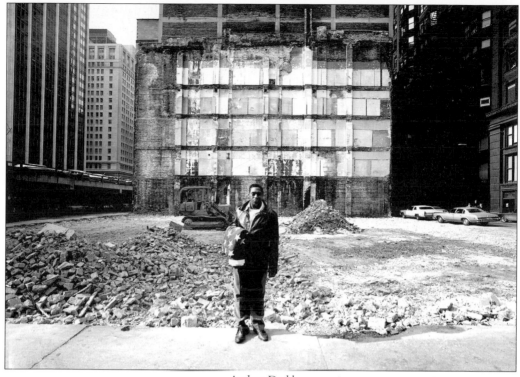

Arthur Dodd

On Van Buren Street, between Dearborn and Clark, the National Cafeteria and the Esquire Hotel stood. When I first came down to the South Loop in 1977, the National Cafeteria had the best, if not the only, breakfast in the neighborhood. I ate there every day until I was told that it was going to be torn down to make room for a parking lot. I made a few photographs while it was still open and then obsessed over it during its demolition.

In a series of photographs, men seemed to be streaming out of the old Esquire Hotel. Later, the half demolished building had a Jane Byrne election poster on it, linking its destruction to progress and politics.

It was while photographing the last heap of rubble that was the National Cafeteria that a man came by and asked me to take his picture. He said his name was Arthur Dodd. He was carrying a giant folded American flag that had been given to him. He was very proud and I was very sad.

—Ron Gordon .

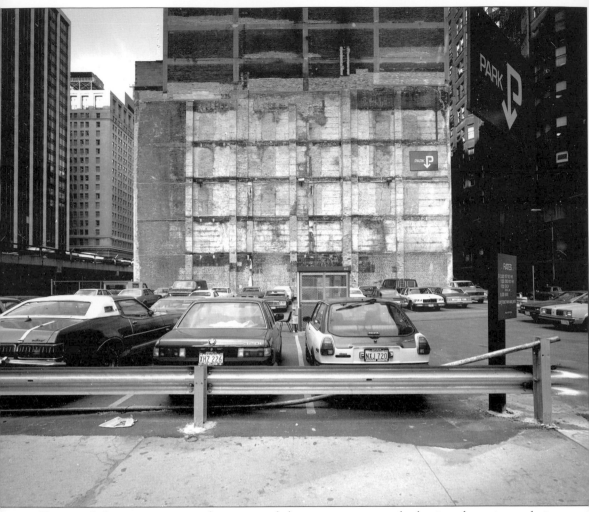

Freeways led to more cars in the congested downtown area as suburbanites drove in to their workplaces. Parking space was at a premium. For many real estate owners and developers, parking lots were more profitable than aging buildings. Countless structures were demolished, displacing people and businesses, to make room for automobiles. The loss of the city buildings affected the livability of the neighborhoods that now became deserted at night when the cars were gone.

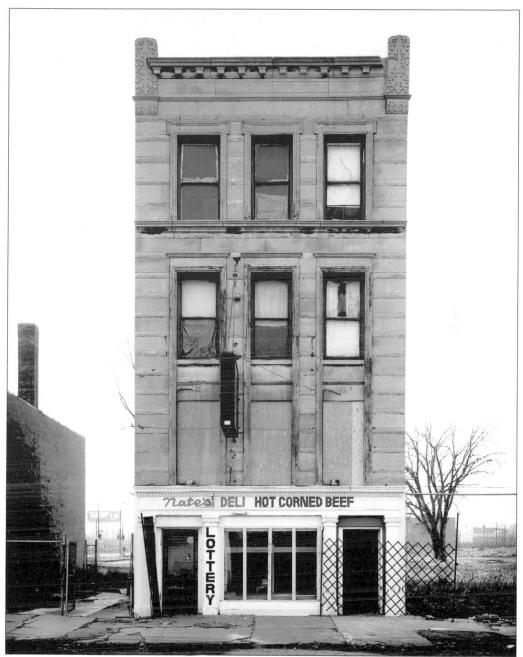

Nate's Deli began as Lyon's Delicatessen in the 1930s. In 1972, Ben Lyons sold it to long time employee Nate Duncan, an African American who had begun working for the family in the 1940s. Nate had worked so long with Lyons that he is reported to have spoken Yiddish. Nate continued to serve kosher food for all of the time he ran the restaurant.

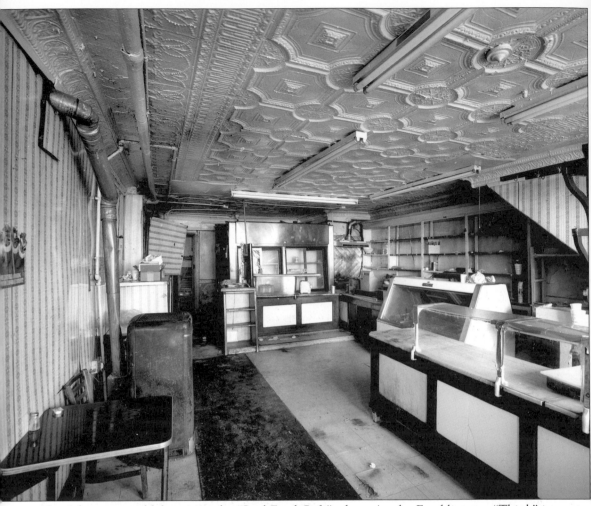

Nate's became world famous as the "Soul Food Café" where Aretha Franklin sang "Think" in the Belushi/Ackroyd film *The Blues Brothers*. Behind the deli was a blues club called the Blues Tree. His "office" was at one of the tables in the restaurant.

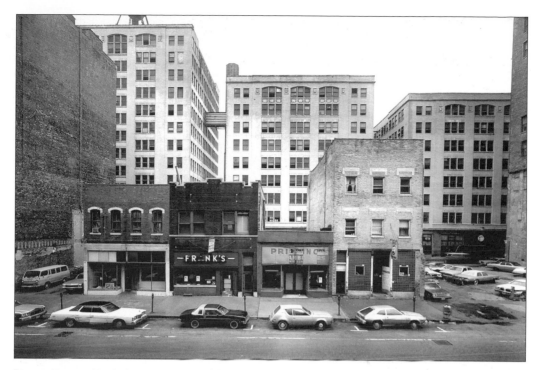

Tony's Diner (far left two-story building) stood in the middle of Printers Row. The Borland Building (Printers Square Apartments) stands tall behind the small row of buildings. The space is now occupied by a small park and fountain. Tony gave a free order of fries with each sandwich. The style of fries varied from day to day and was a popular special with area residents.

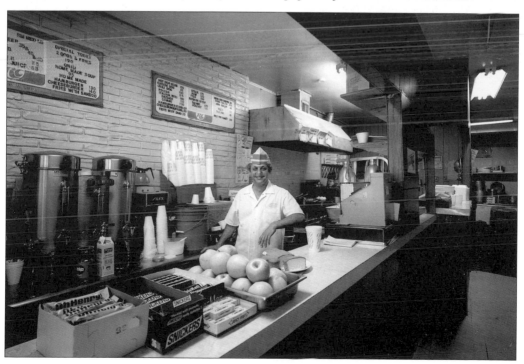

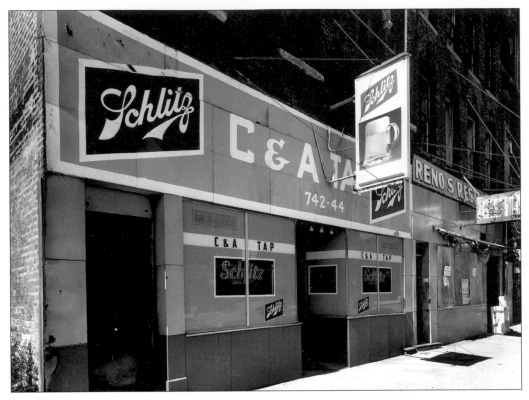

The C&A, Reno's Restaurant, and Tom's Grill served the residents and employees in Printers Row. Tom's Grill has been preserved as a piece of urban archeology but there is a vacant lot where the C&A and Reno's stood.

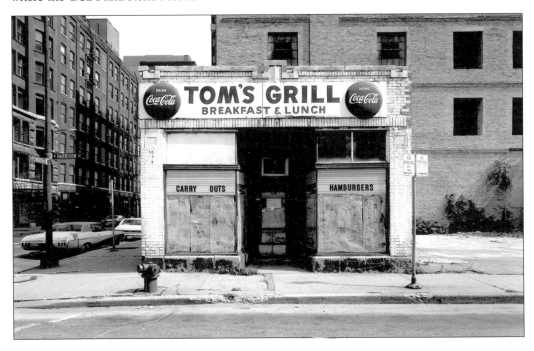

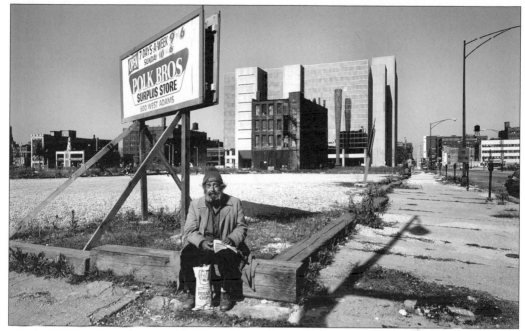

Gerald Lee

It was a Sunday morning when I saw a man sitting on the corner eating Spam and potato chips and reading a book. I asked him if I could take his picture and he said yes. I waited for him to finish his Spam and wipe his face and hands while I set up my old Deardorff. My knees were shaking in front of this scene because I knew it was important and I didn't want it to go away. He told me his name was Gerald Lee as I made a few shots of him. In the background you can see the few remaining single residency occupancy (SRO) buildings where people like Gerald Lee have always found refuge. Behind the old building is the glitzy new Social Security Building. Ironically, the agency whose job it is to care for these people was among the first to put them on the street.

-Ron Gordon

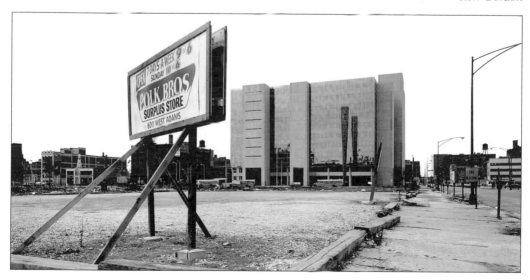

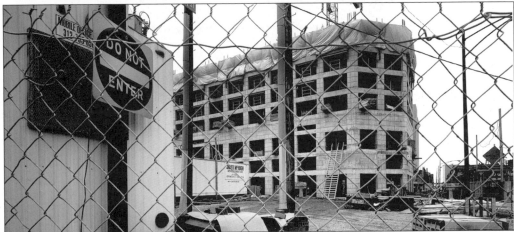

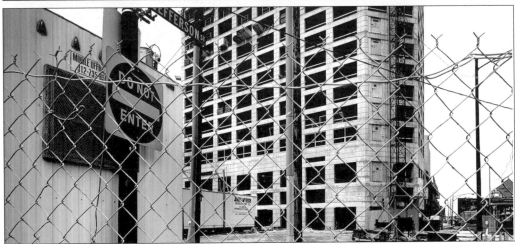

Urban renewal beautifies the city as it replaces older, run-down structures with gleaming high rises but it also displaces the poorest members of society who must move on to find new places to live and eat. The building under construction was part of the Presidential Towers. It now fills the area that was known as Skid Row. Originally, developers agreed to set aside a portion of the units for low income residents but those plans were abandoned.

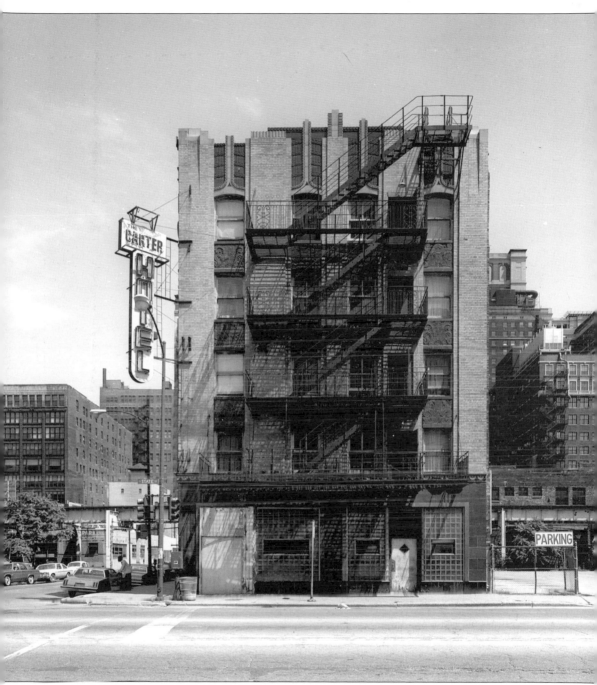

The Carter Hotel Building still stands at State and Balbo. The South Loop Club, a popular night spot, is now in the first floor. The new University Center, an innovative dormitory shared by three universities, is immediately north of the old hotel. The growing magnet school Jones College Prep is across the street. This new population is part of a redevelopment of South State Street which is already bringing new restaurants and other businesses to the area. The Pacific Garden Mission, directly across the street, is likely to be moved in the near future to make room for the development.

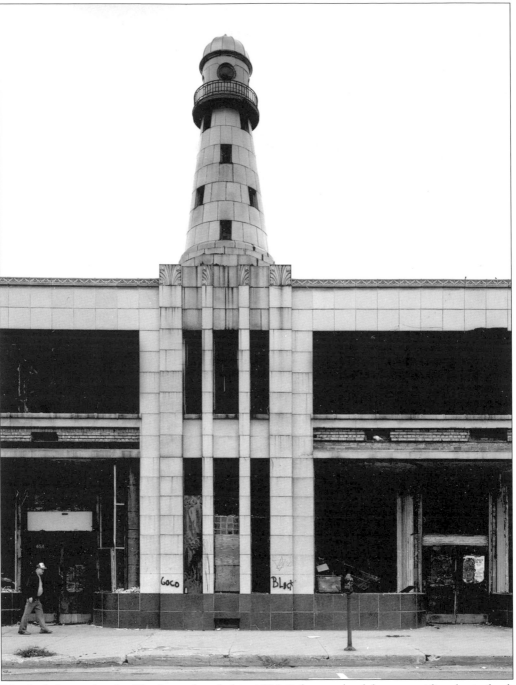

The Lighthouse for the Blind was founded in 1906. It has evolved from providing basic food, clothing, and shelter into a premier advocate for the visually impaired.

Four

FORGOTTEN AND REDEFINED

SOLDIER FIELD, COOK COUNTY HOSPITAL, AND TREE STUDIOS

MANY WORLD FAMOUS artists came to Chicago for the Columbian Exposition in 1893. Judge Lambert Tree, a well-known philanthropist, and his artist wife Anna hoped to convince some of them to stay after the fair closed. The Trees had lived in Europe where they were exposed to artist studios. They decided to build a set of studios behind their mansion (now the site of the Medinah Temple) to house painters and sculptors who could live and work in a community atmosphere. The result was the Tree Studios, built in 1894 and for many years the oldest operating artists' studios in the nation.

The building is a lovely Queen Anne-style structure with skylights and large windows meant to provide abundant light for the artists. On the front are an artist's palette and the inscription "Art is long. Time is fleeting." In 1912 and 1913, additional wings were added enclosing the courtyard with a U-shaped building. With the additions, the number of studios totaled 50. The annexes used different styles of architecture (Arts and Crafts on the Ohio Street side and European Modern facing Ontario Street).

The communal living in the studios created certain limitations. Early leases included riders such as "No cooking of strong odors or foods such as fish or cabbage." and "No playing of the piano or any loud music until after 5 p.m." The tenants shared central bathrooms. To avoid immodest moments, a sign was posted: "In consideration of visitors, all models are required to wear a garment when leaving the studio to walk to the bathroom."

Although the Tree Studios were spared demolition, the artists' studios were closed in 2000. The interior was drastically altered and the spaces developed for retail and office suites. The high price of real estate in the center of Chicago had made an artists' colony obsolete.

There is always controversy when a beloved building is changed. Probably no modernization in Chicago history has engendered such strong feelings as the installation of a modern football stadium inside the historic colonnades of Soldier Field. One of the ironies of the conversion to an exclusive football facility is that the stadium was not built to be exclusively used for baseball or football (unlike many other stadiums erected in the 1920s). The original mission was to be "a showcase for events and a playground for all people." Football would not come full time to Soldier Field for many years.

Noted Chicago architects Holabird and Roche won a competition to build a memorial to American soldiers who had died in wars. The building was constructed between 1922 and 1928 by the South Park Commission. In 1934, the commission and the stadium would be consolidated into the Chicago Park District. The official opening was October 9, 1924—the 52nd anniversary of the Chicago Fire. At this time, it was called the Municipal Grant Park Stadium and it seated 45,000 people. It was renamed Soldier Field in 1925 and formally dedicated during the Army–Navy game on November 27, 1926.

Among the uses envisioned for the park were horseshoes, winter sports, cricket, and cycling. Large events were planned as only occasional occupants in what was supposed to be a large park

area. Seating continued to expand though as the stadium neared completion and the pattern of large sporting events there was set—leaving the playground idea forgotten. In 1928, the stadium sat 70,000 people on pine bleachers. Temporary seating could be added in the infield to increase that number to over 100,000. Large crowds became routine at Soldier Field. The 1926 Army–Navy game attracted 110,000. The legendary 1927 Dempsey–Tunney rematch featuring the controversial long count drew 104,000. Incredibly, a high school Prep Bowl game in 1937 brought 115,000 people to see Austin play Leo.

Football gradually became the dominant event of Soldier Field. For many years, it hosted the College All-Star game which pitted the best new rookies against the NFL Champion from the previous year. In 1971, the Chicago Bears began to use the stadium as a regular season home. And so the memorial built as an all purpose "playground for the people" became a stadium now used exclusively for professional football. Besides the architectural alterations, the mission of the park is changed forever.

When modern medicine could no longer be practiced in the old Cook County Hospital, a controversy began regarding the value of the building. Preservationists, developers, and some county officials argued about the worth of the building and the feasibility of recycling it for new uses. Lost in the argument is a history that stretches back before the incorporation of the City of Chicago.

In 1835, Cook County opened the Poor House to provide free medical care for indigents. By 1847, the Poor House was unable to meet the needs of the growing population and the County rented Tippecanoe Hall at Kinzie and State, which became the first Cook County Hospital. Three years later, the hospital closed and the poor were sent to the Illinois General Hospital which had been founded by doctors in Chicago. A year later, the Catholic Sisters of Mary took over control of the hospital. The hospital was incorporated as Mercy Hospital. The county sent indigent patients to Mercy and paid for their care. Finding the care inadequate, the county procured a facility from the United States Government and founded the new Cook County Hospital in 1866. In 1874, the county purchased the land at Harrison, Polk, Wood, and Lincoln Streets which is the location of the current hospital. A facility was opened there in 1876 and served the growing needs of the exploding Chicago population. By 1910, overcrowding was again a problem and the board voted to build a new hospital, which opened in 1914. This is the main part of the building that stands today.

As years went on, a variety of new pavilions were added dramatically increasing the number of beds at Cook County. By 1928, the hospital could accommodate 3400 patients. In 1929, a school of nursing was established which continued to offer nursing certificates until 1981. By the 1930s, Cook County began a set of medical "firsts" establishing itself as one of the preeminent medical facilities in the nation. The first blood bank was opened there in 1937. In 1953, the first cobalt beam therapy unit for cancer patients in the Midwest was opened. It was one of only three in the nation. The year 1955 saw the opening of the first advanced radiographic room in the world designed for technical examination of chambers of the heart and brain tumors. By 1991, the emergency room was one of the busiest in the world treating over 110,000 patients annually. Cook County became the model for the highly fictionalized doctors of the popular television show *ER*.

In 2002, a new state of the art hospital replaced the aging facility offering quality healthcare to the citizens of Cook County without regard for their ability to pay. There is now a controversy about what should be done with the historic structure. Some county officials feel it should be torn down to make way for new develop. Preservationists argue that it can be put to good use as new development thus preserving its beauty and history.

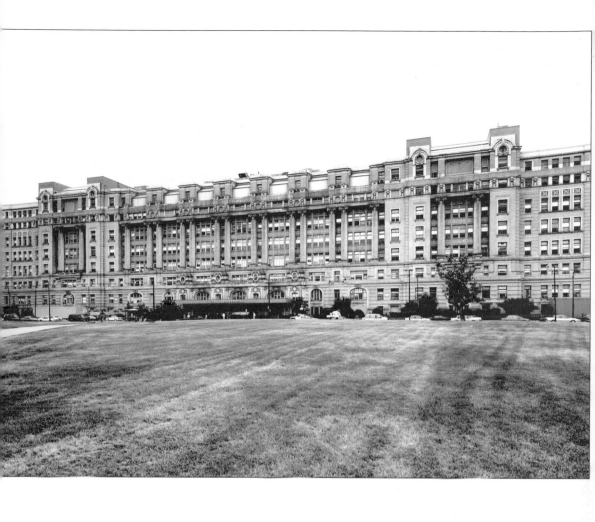

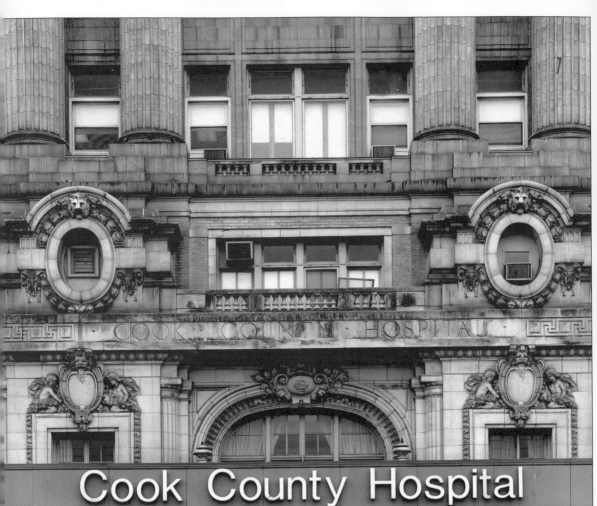

Cook County Hospital

Ornate detail and imposing columns are among the architectural features that would be lost if Cook County Hospital is demolished. The building has a rich history in Chicago. Many feel it should be converted to residential units. County officials have stated that fixing current fire code violations would be too expensive. Preservationists argue that the cost of demolition is higher and that the recycled building would add new property taxes.

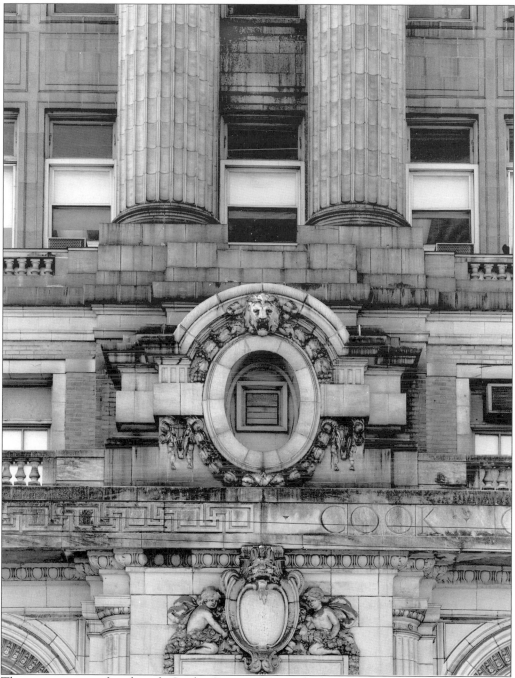

The terra cotta façade of Cook County Hospital shows stunning detail below its towering columns.

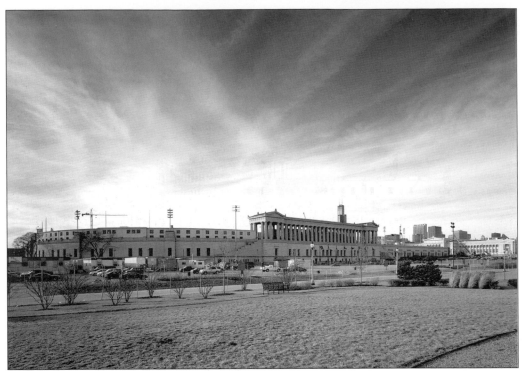

The great colonnade dominated Soldier Field before its renovation. Originally conceived as a playground for all Chicagoans, it quickly became a venue for large events. It was intended to hold a variety of events and activities but now will be used exclusively for professional football.

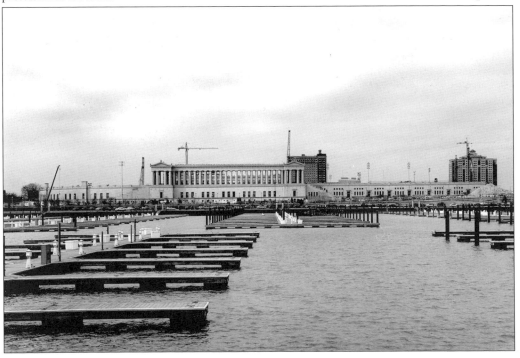

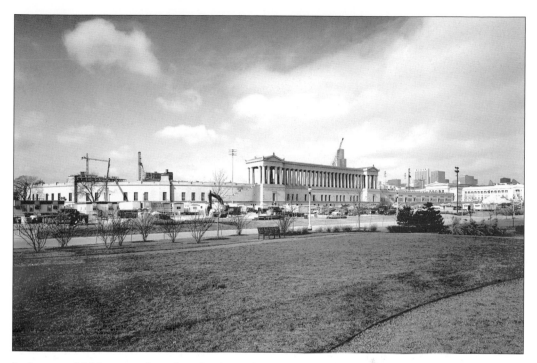

In January 2002, just a day after the Bears lost a playoff game, crews began to tear the seats out of Soldier Field. Soon cranes rose above the old park to begin construction of the new football stadium.

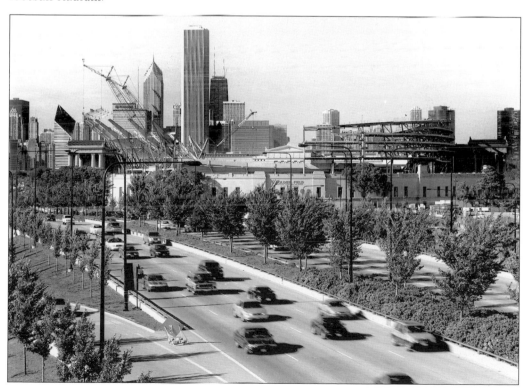

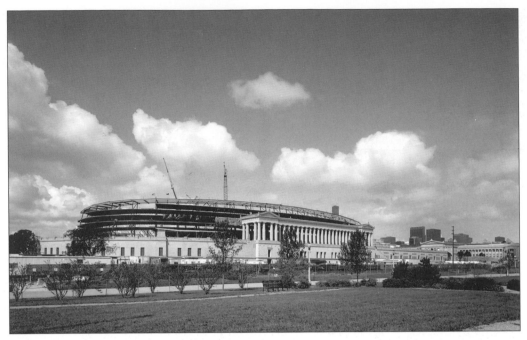

The inner bowl rises above Soldier Field dwarfing the historic columns. The new Soldier Field contains 575,000 square feet of new metal decking (enough to pave two city blocks, or if laid end-to-end in a one-foot swath to stretch 108 miles), 30,000 square yards of carpeting, 190,000 square feet of glass curtain wall, 14,000 light fixtures, 20,000 circuit breakers, 1.25 million watts of sports lighting (enough to light 500 average households), and 1,600 doors.

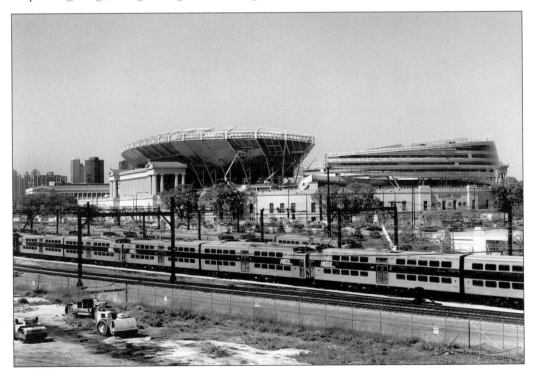

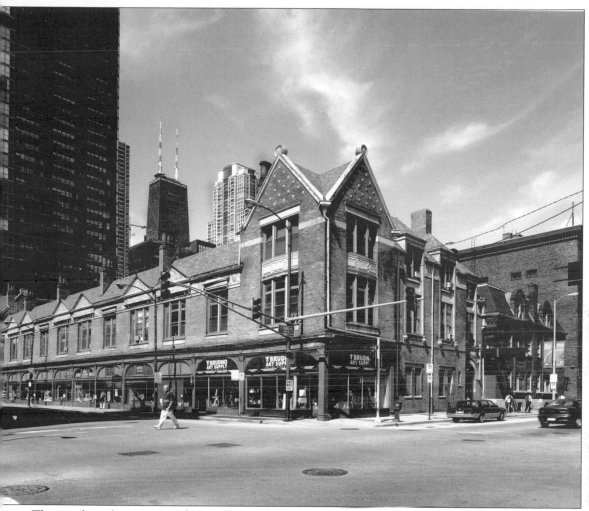

The north and west sides of Tree Studios demonstrate contrasting architectural styles. Three different faces of the building create an astonishing unity. Judge Tree's mansion was to the right where the Medinah Temple now stands.

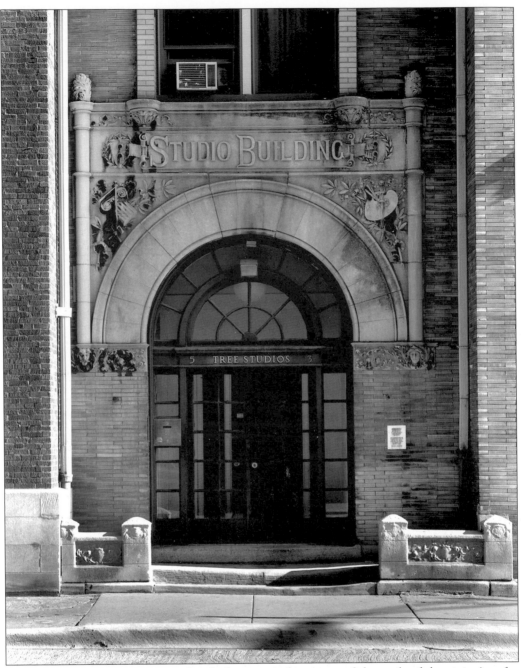

The graceful entrance was carved with decorative depictions of the tools of the artists' crafts. The stoop shows the wear from years of comings and goings. The State Street Building was designated a landmark in 1997. The two annexes received the same designation in 2001.

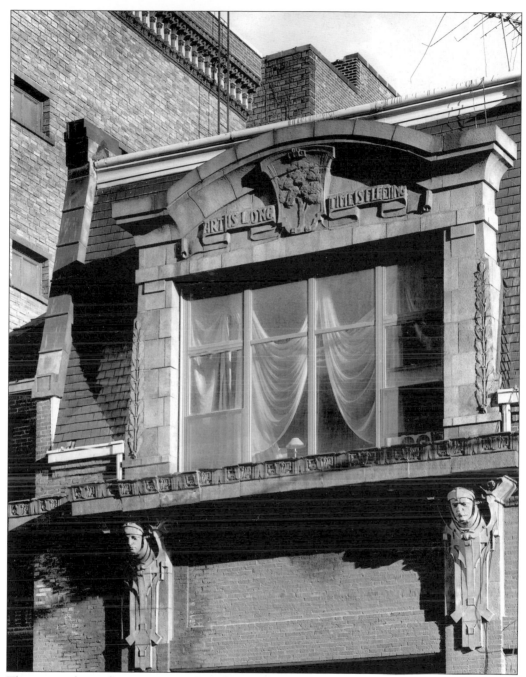

The quote above the entrance is from Henry Wadsworth Longfellow: *Art is long, and time is fleeting, / And our hearts, though stout and brave , / Still like muffled drums are beating / Funeral marches to the grave.* It is probably based on a quote from Hippocrates which is better known in Latin: *Ars longa, vita brevis est.*

Inside the courtyard was a quiet garden. The motto of the City of Chicago, found on its seal, is *urbs in horto*—a city in a garden. The Tree Studios created *hortus in urbe*—a garden in a city.

The building was erected with painters in mind, but throughout the years a wide variety of artists lived there including writers, poets, musicians, filmmakers, architects, photographers, and illustrators.

Among the more famous residents are actors Peter Falk and Burgess Meredith, J. Allen St. John (who illustrated the Tarzan books), sculptor John Storrs (who created the Ceres statue on the top of the Board of Trade), muralist John Warner Norton, and Marya Lillien (an interior designer and professor at the School of the Art Institute).

Five

FORGOTTEN MARKET
THE LAST DAYS OF MAXWELL STREET

A BOOMING MARKET existed as early as 1910 in the area south of Roosevelt Road (then 12th Street). Immigrants crowded the West Side of Chicago at the turn of the century. Pushcart vendors provided a variety of goods to the working men and their families. Gradually, these vendors began to congregate on Maxwell Street providing a central shopping area for every imaginable nationality or ethnic group. In 1912, a city ordinance created the market on Maxwell Street, transforming one of the earliest residential streets in Chicago into a shopping area that would endure for almost a century. A tradition of bartering and discount shopping created in the early years of the 20th century would remain the hallmark of the market for 90 years.

In many ways, Maxwell Street was always the most integrated area of Chicago, attracting people of all races and countries of origin. Jews from Eastern Europe, African Americans who came north from Mississippi during the Great Migration, Hispanic immigrants and many others crowded into the cramped quarters of Maxwell Street. The neighborhood went through many ethnic transitions, with each group leaving behind some of its character and traditions. For decades, Chicagoans of many backgrounds met at Maxwell Street to shop, eat, and experience each others' cultures.

The market area provided both convenient, inexpensive goods for shoppers and a livelihood for vendors. The concentration of people also drew African-American musicians who could not find employment in white-only music clubs. In particular, blues players from the South began to gather on Maxwell Street and play in the open air market. In the 1920s, guitar manufacturers had responded to the growth of recording and band music by attempting to make louder instruments. By the 1930s electrically amplified guitars began to become available. Faced with the need to be heard in the loud market of Maxwell Street, southern blues players plugged amplifiers into the stone outlets installed to provide electricity to the street vendors. This fusion of the jazz band style amplified guitar with Mississippi style blues created Chicago Blues—a loud, raw style of music that would become a major influence on such rock musicians as The Rolling Stones, Jimi Hendricks, and Eric Clapton. The pioneers of the Blues could be found playing outside in the market often even after they had achieved recording success. A visitor to Maxwell Street might hear Muddy Waters, Howling Wolf, Little Walter Jacobs, Big Bill Broonzy, or Jimmy Lee Robinson among many, many others.

The strong Jewish presence on Maxwell Street helped to give rise to one of its most famous traditions—the Sunday Market. Closed on Saturday for the Sabbath, Jewish merchants would open their shops and stalls for business on Sunday morning. The area was adjacent to a number of large immigrant churches. Many parishioners would come directly from church to shop in the market. The Sunday shopping became a tourist attraction drawing people from throughout Chicago and the nation. Many came for the interesting goods and many others visited to see one of the birthplaces of the Blues.

The market suffered from the same deterioration and petty crime as other parts of the city, although attention always seemed to focus on the problems of Maxwell Street. As years went on, the boundaries of the market shifted and the character of the neighborhood continually changed. The dense population of the area created difficult and unsanitary living conditions. An 1891 survey showed that 16,000 people lived on a one-mile stretch of Maxwell Street. As years passed, the ghetto-like setting became home to one group of new arrivals to America after another. By the middle of the 20th century, the city of Chicago had begun to neglect the maintenance of infrastructure in Maxwell Street. As "urban renewal" became the policy of the city in the late 1950s, Maxwell Street was seen as a blight that needed to be removed. The construction of the Dan Ryan Expressway cut off part of the eastern border of Maxwell Street. Mayor Richard J. Daley selected Halsted and Harrison to be the site of the campus of the University of Illinois—Chicago. The creation of the university site displaced over 14,000 residents and 800 businesses. Although the end would be several decades ahead, the site selected for UIC was a death knell for Maxwell Street.

In 1990, the University announced plans to acquire land south of Roosevelt Road to expand its campus. The city government strongly supported this expansion. City sanitation in the area was cut and police staff was decreased. Many residents and businesses felt that the city was intentionally creating an unlivable slum by its neglect. Since 1912, the city of Chicago had been deeply involved in the regulation and maintenance of Maxwell Street. When its support was at least tacitly withdrawn, the area declined quickly.

In the final years, the decrepit state of the buildings on Maxwell Street seemed to prove the point of urban renewal advocates. Buildings were abandoned and falling apart. Alleys were filled with trash and homeless people were occupying many of the empty spaces. The intentional abandonment of the area by the city was finally admitted by the Department of Planning in 1992 when it selected a new site for the market at Roosevelt and Canal.

A wonderful portrait of the vibrant history and people of the market can be found in the book *Chicago's Maxwell Street* by Lori Grove and Laura Kamedulski (Arcadia, 2002). In it, the reader will find the pictures of the rich past and colorful activities that were found just south of Roosevelt. Here you will see a sadder story of the final years of neglect and demolition. Preservation groups fought long and hard battles to save the special folk character of Maxwell Street. Their efforts would prove to be unsuccessful. In 1994, the market was relocated and the final destruction of the street went forward. Businesses that had stretched back 70 and 80 years left the area or closed up and the buildings that housed them were reduced to rubble. While a reminder of the market goes on in the new location on Sunday mornings, the vitality of Maxwell Street has been largely forgotten.

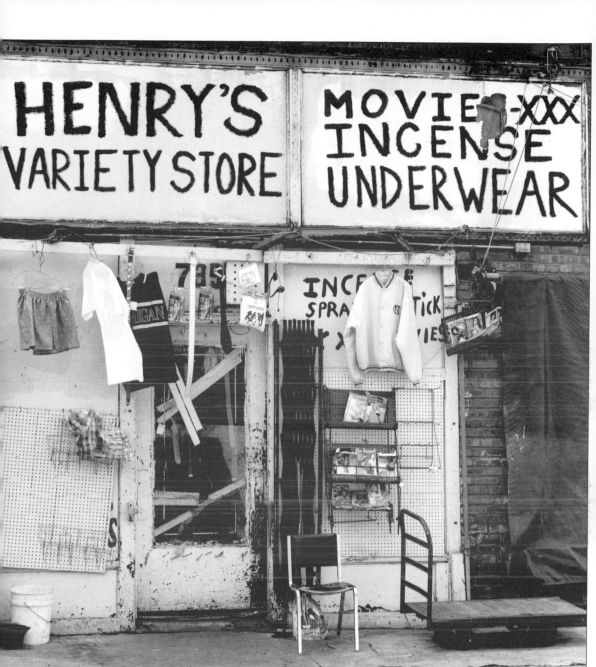

A certain chaotic blend had always been part of Maxwell Street's charm. Henry's allowed shoppers to buy movies, incense, and underwear all under one roof. The magazine racks have a variety of suggestive material.

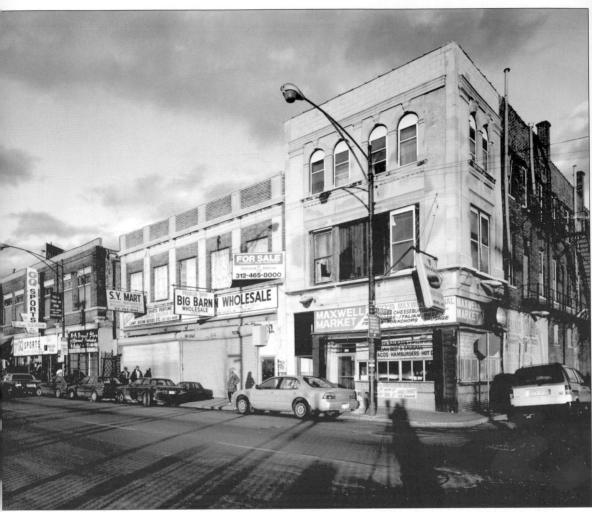

Almost every corner of Maxwell Street had a hot dog stand such as the Maxwell Market. The Vienna Sausage Company opened a sausage shop at 12th and Roosevelt after the hot dog made its debut at the Columbian Exposition in 1893. They manufactured sausage in the back and sold it in a store in the front. The company helped establish a number of outlets on Maxwell Street. Since the product was made just blocks away, Maxwell Street became known for the best and freshest hot dogs in Chicago.

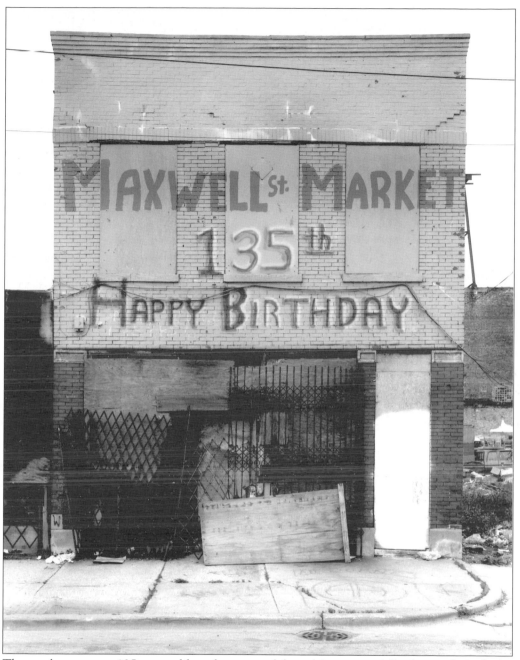

The market was not 135 years old so the cause of the celebration is difficult to tell. Still, the sign showed the strong sense of pride that was emerging as groups such as the Maxwell Street Preservation Coalition worked to save the area.

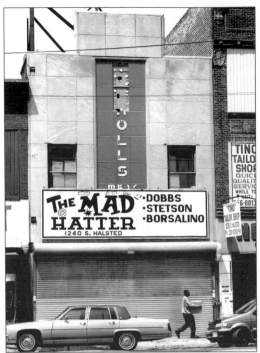

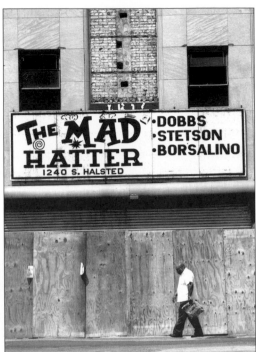

Clothing and tailoring were a main part of the business of Maxwell Street. Many of the stores began on Maxwell Street and then moved onto Halsted. Gabel's was the largest store in the 1950s. Stores such as Smokey Joe's sold flashier clothing. The Mad Hatter sold the finest brands of men's hats. Its graceful Deco façade gave way to crowbars.

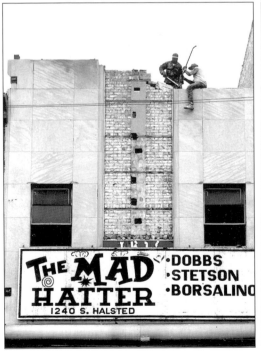

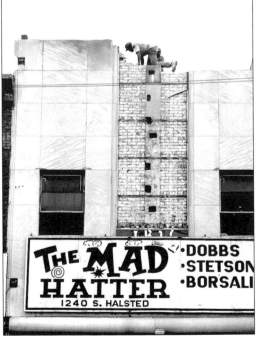

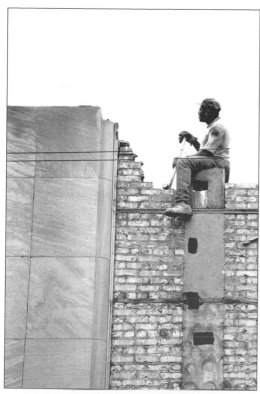

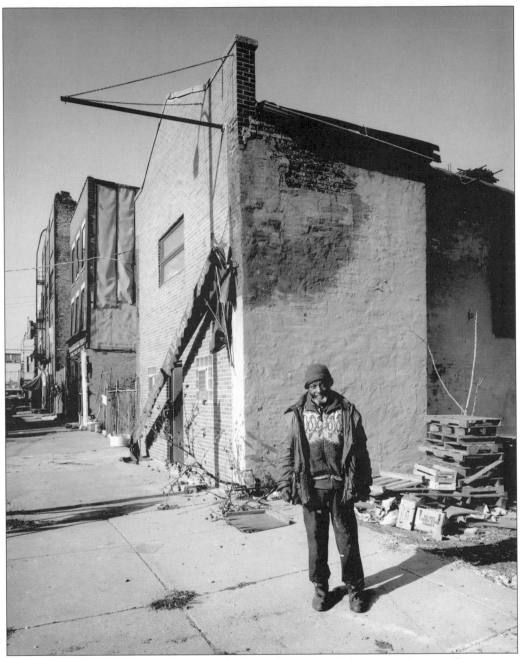

Approximately 166,000 people experience homelessness in Chicago each year. On average, people are homeless for six months. Many of the chronically homeless gravitated to areas such as Maxwell Street in its later days to take shelter in the abandoned buildings.

The *mezuzah* contained a handwritten passage from the Torah and was installed on doorways by Jewish residents. This *mezuzah* was in a building that served as a synagogue, a kosher butcher shop, and a residence for the rabbi who operated them all.

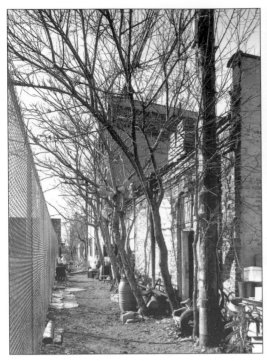

By the last years, the city of Chicago had almost stopped services to Maxwell Street and trash and decay took over the area. This deterioration supported the argument of developers who wanted to raze the area because it had become a slum. The trees are filled with baby dolls—another bit of Maxwell Street whimsy.

 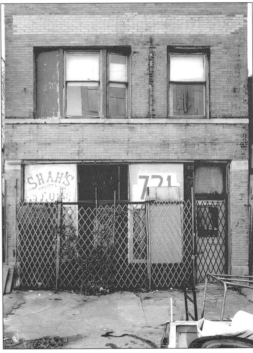

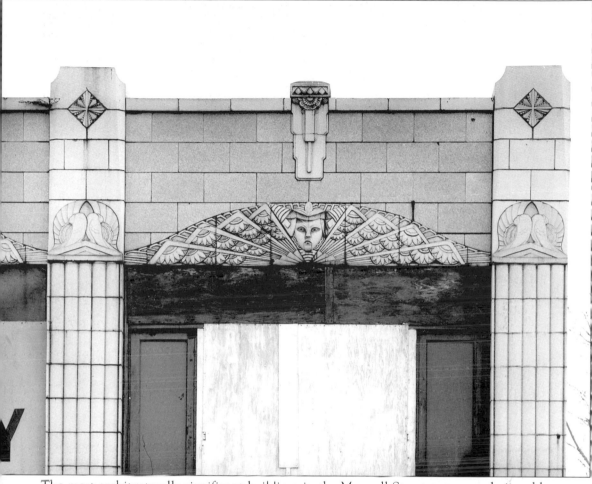

The most architecturally significant buildings in the Maxwell Street area were designed by Joseph Cohen in the 1920s. Cohen was a prominent local Jewish architect who worked with a number of the property owners in the Jewish community. His buildings in the area were marked by sophisticated use of terra cotta façade. The Commission on Chicago Landmarks found five buildings around Maxwell Street to have "architectural significance in the context of the community."

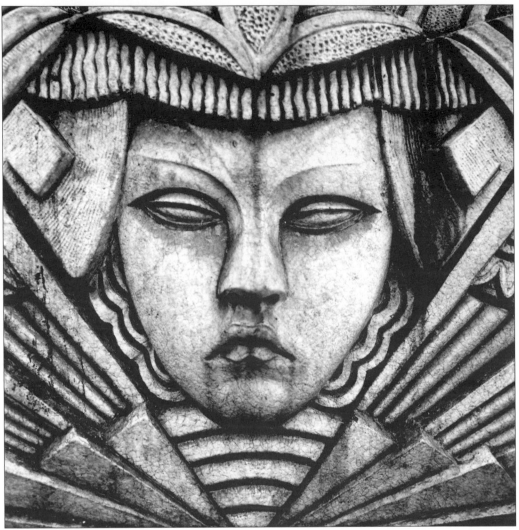

The terra cotta façade combined Gothic decoration with Art Deco style. The straight, clean lines and perfect symmetry identify the face's origin in the 1920s. In the full shot of the building, the eyes of the figure were open. In this close up, the eyes are closed suggesting it came from the other side of the building.

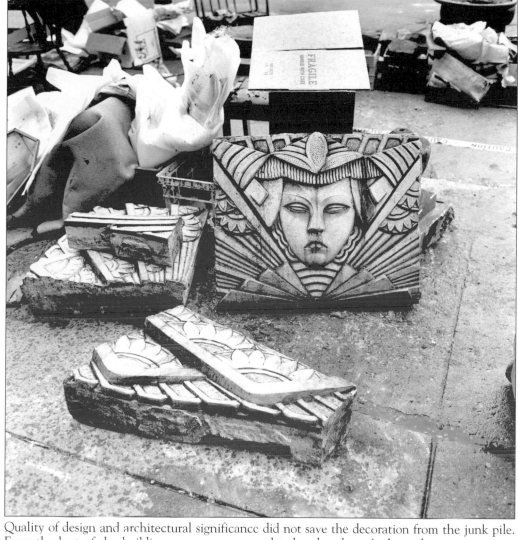

Quality of design and architectural significance did not save the decoration from the junk pile. Even the best of the buildings were seen as outdated and useless. At best, the ornament was salvaged. More often, the entire building was demolished. Collectors often picked up the pieces.

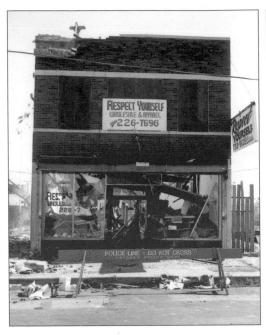
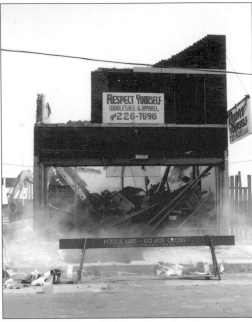

Maxwell Street stores frequently had colorful names such as "Cheat You Fair" Wholesale and "Respect Yourself" Apparel. Respect Yourself also provided employment to the needy in the area. These establishments provided discount shopping to people from all parts of Chicago. As the building was destroyed, the opportunity for inexpensive, convenient goods was lost as well.

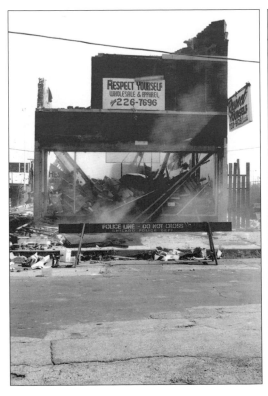
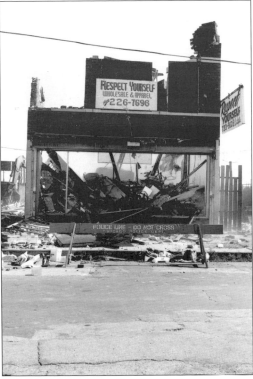

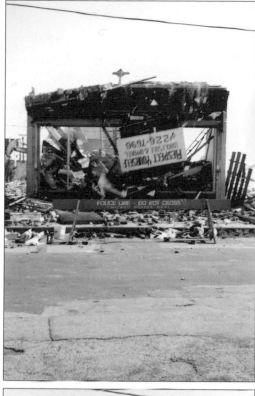

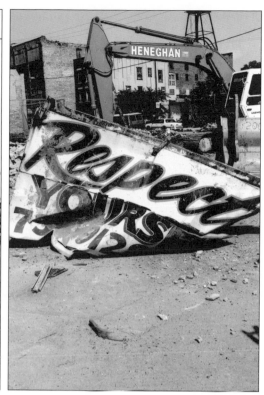

111

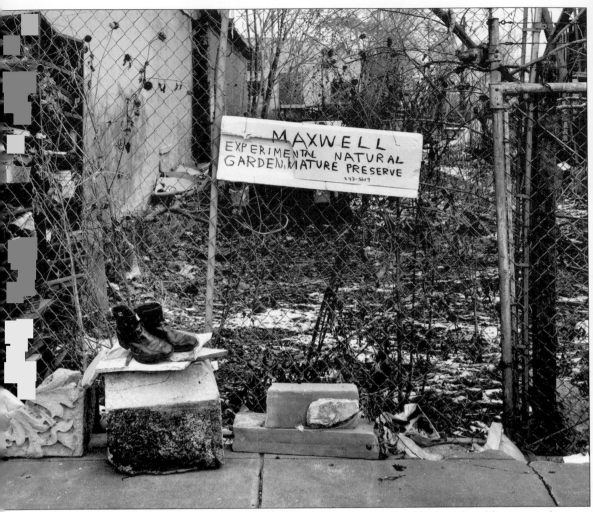

The Maxwell Street Historic Preservation Coalition frequently developed public art and performance pieces to bring attention to the unique character of the area. Some showcased the links of famous people to the street. Others satirized the declining condition of the neighborhood due to official neglect.

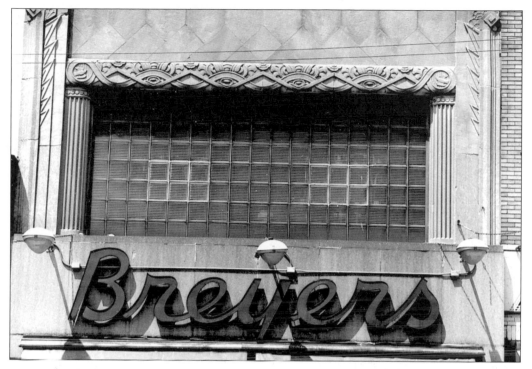

Breyer's Hats was founded by Adolph Breyer in 1895. This store on Halsted was built in 1928. The family owned it through two generations. The building would eventually be occupied by other businesses but it would always carry the Breyer's names. Although best known for hats, Breyer's eventually became a general men's clothing store. The face of the building shows the same intricate terra cotta styling. The combination of glass and decoration creates a beautiful lightness that stands out next to the adjoining brick structure.

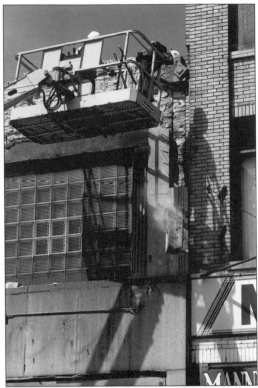

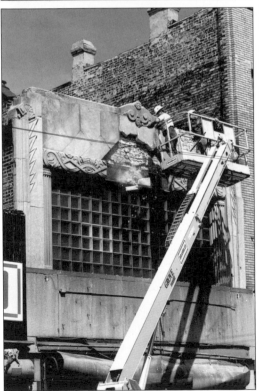

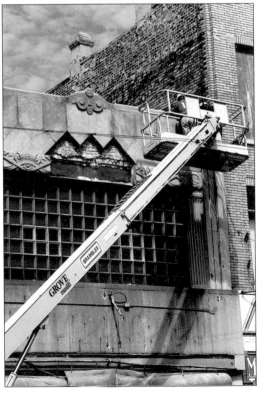

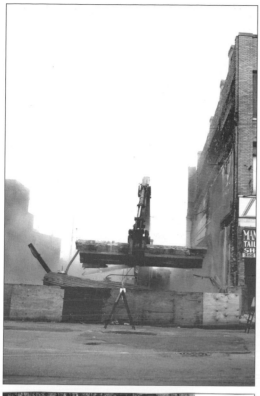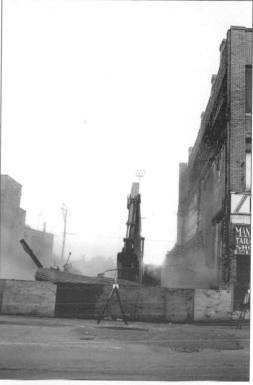
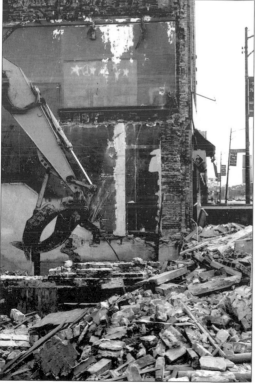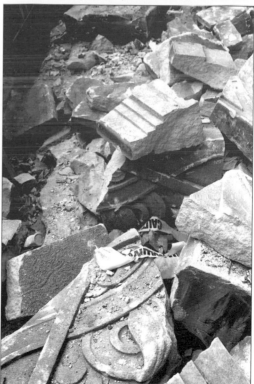

The struggle to preserve Maxwell Street took place over three decades. As early as the 1960s, activists such as Florence La Scala of the West Side Planning Board fought against the selection of the Harrison–Halsted site for the University of Illinois–Chicago. Protests were held but the drive was unsuccessful. The university opened in the old immigrant area in 1965. The Maxwell Street Historic Preservation Coalition and the Maxwell Street Vendors Association held protests and promoted walking tours to demonstrate to Chicagoans that the market area was still a vibrant community. Various attempts were made to secure landmark status for the area. They also proved unsuccessful. Some efforts, such as the drive to keep the Hispanic mission open at St. Francis of Assisi Church, met with a better end. The Chicago diocese had closed and begun to demolish the church but an "occupation" by parishioners changed the decision. During the controversies, Maxwell Street seemed to sit quietly at night awaiting its fate.

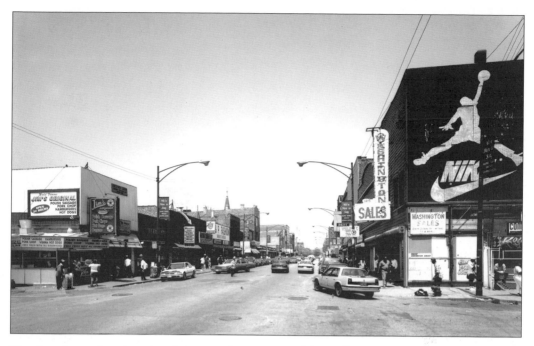

Despite city and university claims to the contrary, Maxwell Street was a busy commercial area. The streets became abandoned only under the pressure of neglect of city services and the wrecking ball.

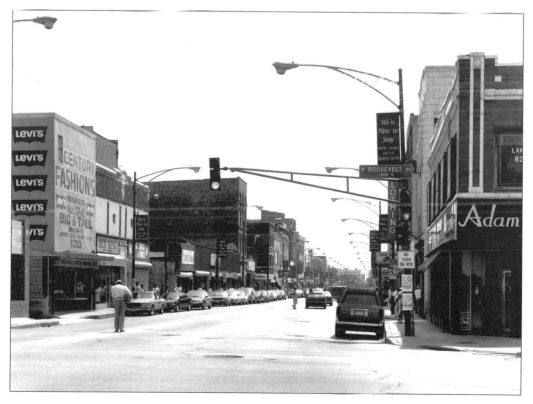

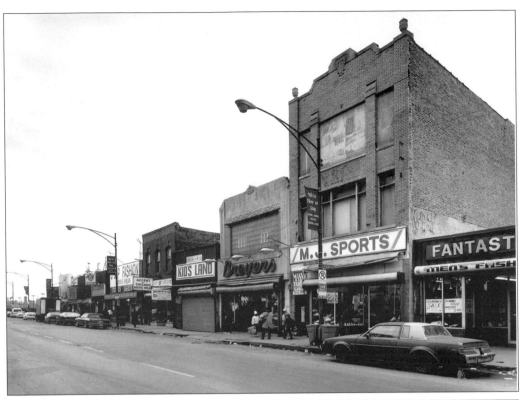

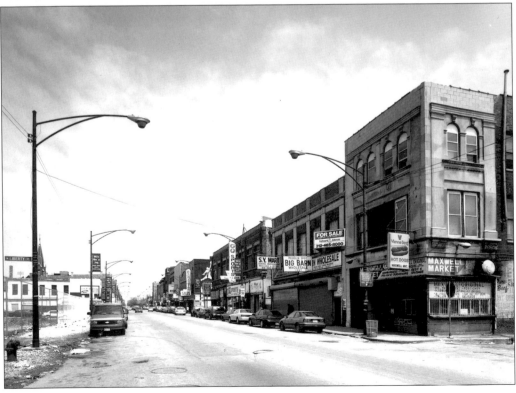

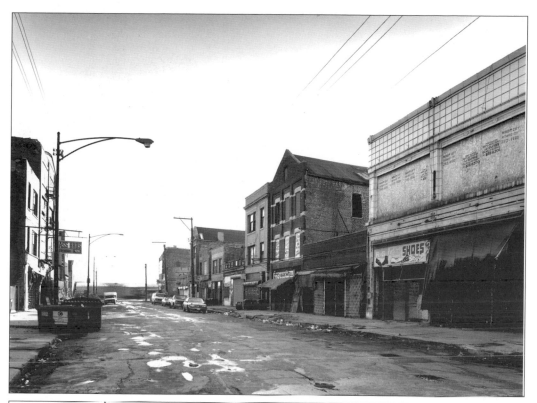

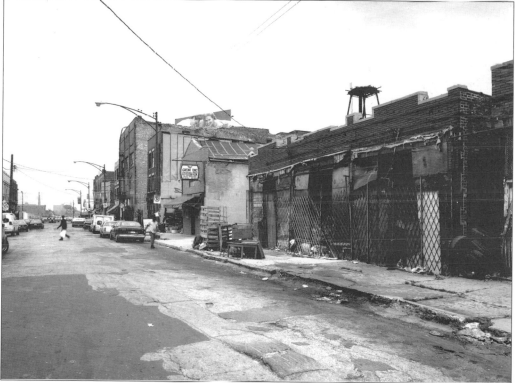

Tailoring and clothing stores were a main part of the Maxwell Street economy from the earliest days. Jewish immigrants began to arrive from Russia and Eastern Europe in the late 1880s. Most of them settled in Maxwell Street.

Jewish immigrants frequently became self-employed, opening a variety of stores. Many had worked making clothing in the Old Country and were skilled tailors and shirtwaist makers. In the early years, sweatshops filled many Maxwell Street tenements. By the later years, clothing shops and general line merchants occupied the storefronts.

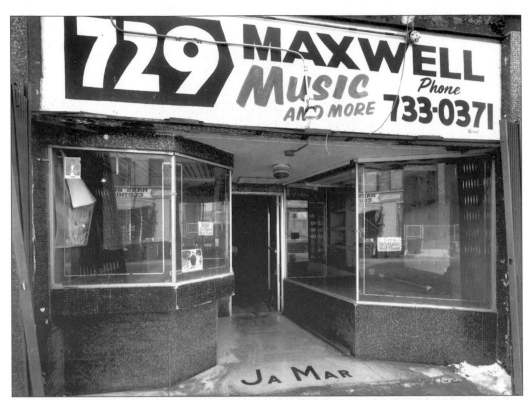

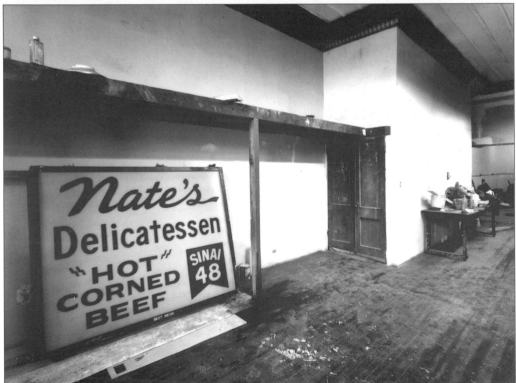

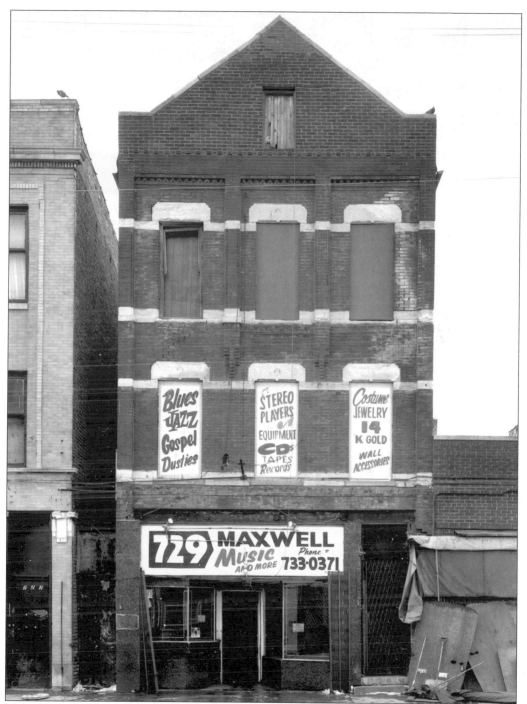

Music and food were always main attractions to Maxwell Street. The deep history of the area in the blues inspired local musicians such as Mike Bloomfield who would play with the Paul Butterfield Blues Band. It was a frequent destination for rock musicians who recognized their roots in Chicago Blues. Nate's was a natural site when the title of a movie was *The Blues Brothers*. None of that saved the businesses and buildings from being dismantled.

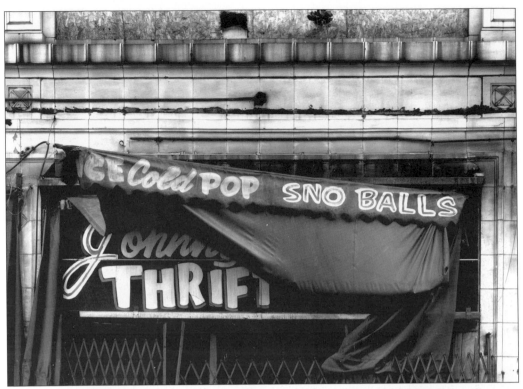

For nine decades, Maxwell Street was about shopping. From pushcarts to outdoor stalls to discount vendors, the waves of immigrants to Chicago came to Maxwell Street for affordable products. Whether it was clothing or jewelry, it could be found in the market.

ACKNOWLEDGEMENTS

THE AUTHORS WOULD like to gratefully acknowledge the assistance of Chris Ferrari for darkroom work, Sandy Steinbrecher for darkroom work and proofreading, Emma Rodewald for help in organizing the photo archive, Samantha Gleisten for her encouragement and support of this project, Sallie Gordon for her love and support, and Colleen Kelley for her love and encouragement. They would like to give special thanks to Sandmeyer's Bookstore for their continued support. Particular notice needs to be given to Lori Grove and Laura Kamedulski's book *Chicago's Maxwell Street*, which can be found in this same *Images of America* series —their research on Maxwell Street was invaluable. Information about preservation was freely given by Lisa Stone and Kristin Armstrong and we are grateful for their help.

PHOTOGRAPHS

All photographs are by Ron Gordon except archival photographs which were obtained through the public domain or the Chicago Public Library.

AUTHOR BIOGRAPHIES

Ron Gordon is co-author of *Printers Row* (Arcadia, 2003) and *Ron Gordon's Selected Photographs*. He is a professional photographer who has been chronicling the work of preservation in Chicago for almost 30 years. His work is in the permanent collection of the Art Institute of Chicago, the Museum of Contemporary Photography, the Illinois State Museum, and has been featured in numerous exhibitions. He has worked on photographic portions of movies such as *A River Runs Through It* and *The Fugitive*. His website is www.rongordonphoto.com.

John Paulett is co-author of *Printers Row* (Arcadia, 2003) and *Pentecost, Peanuts, Popcorn and Prayer*. He is also a playwright and musician. In 2003, he gave a performance art piece as part of the art show *Operation Intelligence* in both Chicago and Memphis. His music can be heard on the CD *Quilting Music* by Home Brew. John holds degrees in Classical Languages and Theater and is currently pursuing another degree in education. He can be contacted at jpaulett@sbcglobal.net.